# MARYHILL
## MUSEUM OF ART

*Auguste Rodin's caryatid, extracted from The Gates of Hell, appears to be one of Dante's tormented souls in purgatory, trying to expiate her sin by carrying a huge stone on her back. The stone symbolizes physical suffering and mental anguish, both inescapable human burdens.*

"The whole stone weighs upon each small part of this body like a will that is greater, older and mightier than it; and yet the fate of bearing it has not come to an end. It bears, as in a dream one bears the impossible and finds no deliverance. Even its collapse and failure has remained a way of bearing. And when further weariness arrives and forces this body down so completely that it is lying, then this lying shall also be a form of bearing, bearing without end. Such is the Caryatid."

*Rainer Maria Rilke*

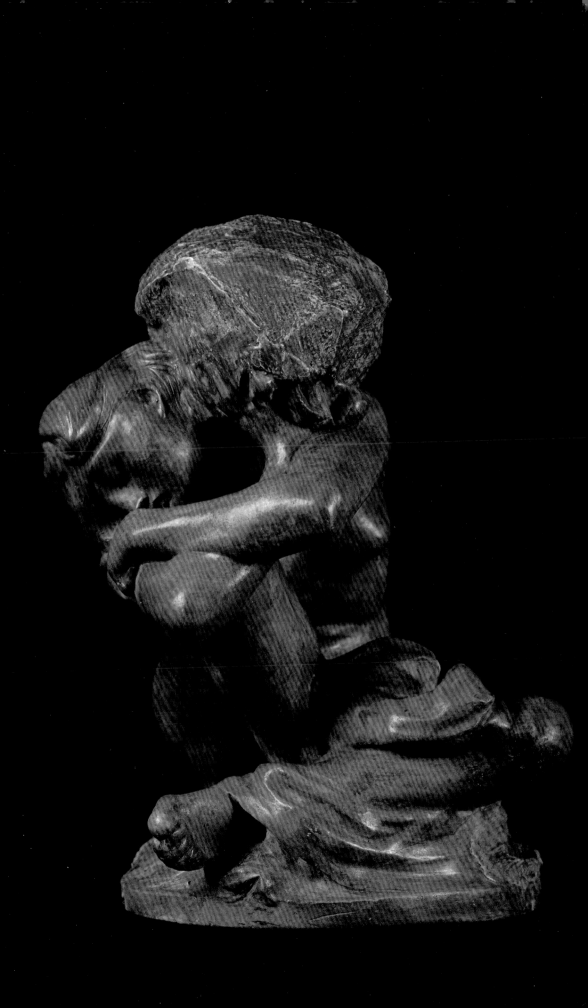

This book would not have been possible without a generous grant from the Bruce and Mary Stevenson Foundation of White Salmon, Washington. The late Mary Hoyt Stevenson, her late husband, Bruce Stevenson, and their daughters, Laura Stevenson Cheney, Anne Stevenson, and Leslie Stevenson Campbell, have been supporters of Maryhill Museum for decades. Their gift of this publication will spread the extraordinary story of Samuel Hill, Queen Marie of Roumania, Loie Fuller, and Alma de Bretteville Spreckels and how they created a museum of art in the Columbia River Gorge.

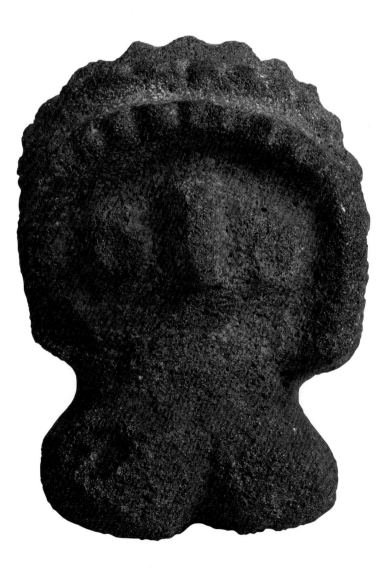

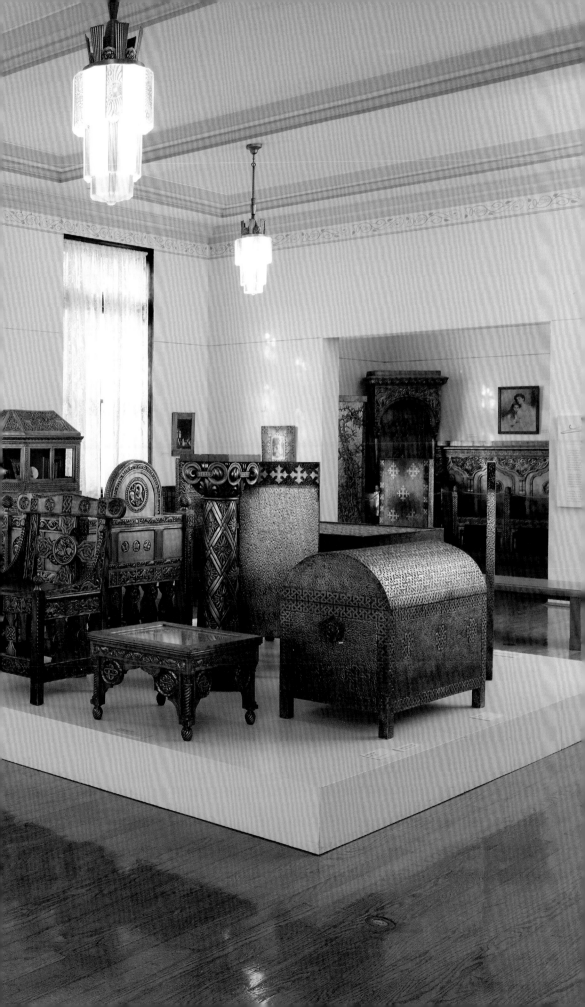

# MARYHILL
## MUSEUM OF ART

Text **Linda Tesner**

Photography **Robert M. Reynolds**

Design **Reynolds Wulf Inc.**

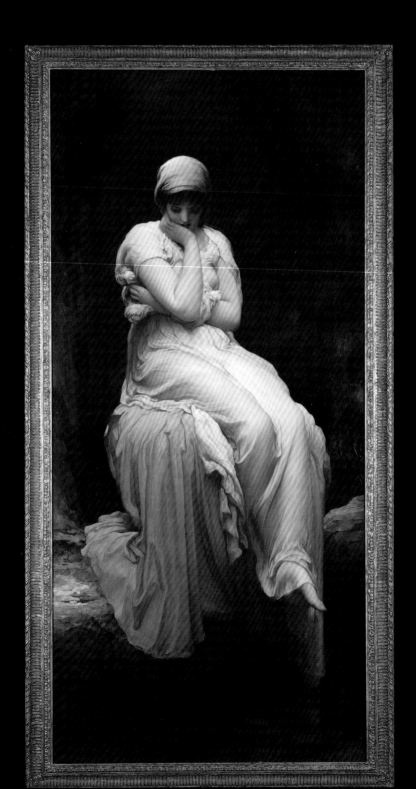

## Contents

Page 3: **Auguste Rodin (French, 1840-1917)**, *Fallen Caryatid Bearing Her Stone,* c. 1881, terra cotta and plaster, 12.5 x 11.5 x 16.5 inches. Gift of Samuel Hill.

Page 4: **Janus Head (Wasco-Wishxam), pre-19th century, basalt, 4 x 3.5 x 8.5 inches. Gift of Bruce and Mary Hoyt Stevenson.**

Left: Frederic, **Lord Leighton (British, 1830-1896)**, *Solitude,* 1890, oil on canvas, **36 x 72 inches. Museum purchase.** Photographer unknown.

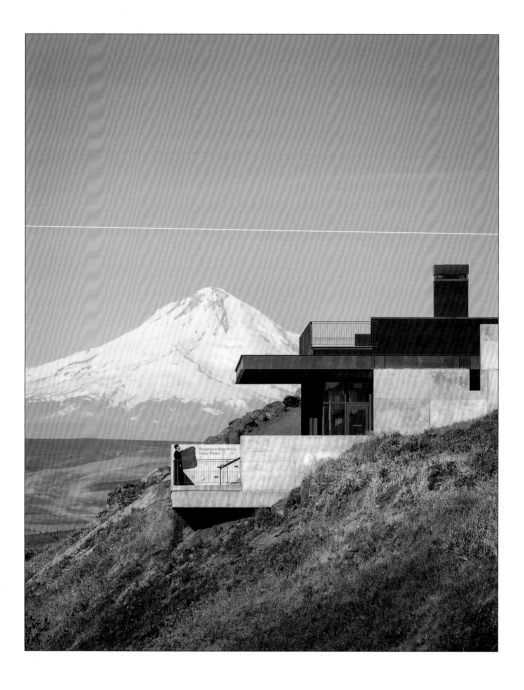

Above: **The Broughton & Mary Bishop Family Terrace with Mt. Hood.**
Photograph by Josh Partee.

Right: **Rex Silvernail (American (1942–2013),** *Orcha II,* **2011, wood veneer strips and laminated wood, 48 x 22 x 84 inches, Gift of Rex Silvernail**

Overleaf: **Maryhill Museum of Art**

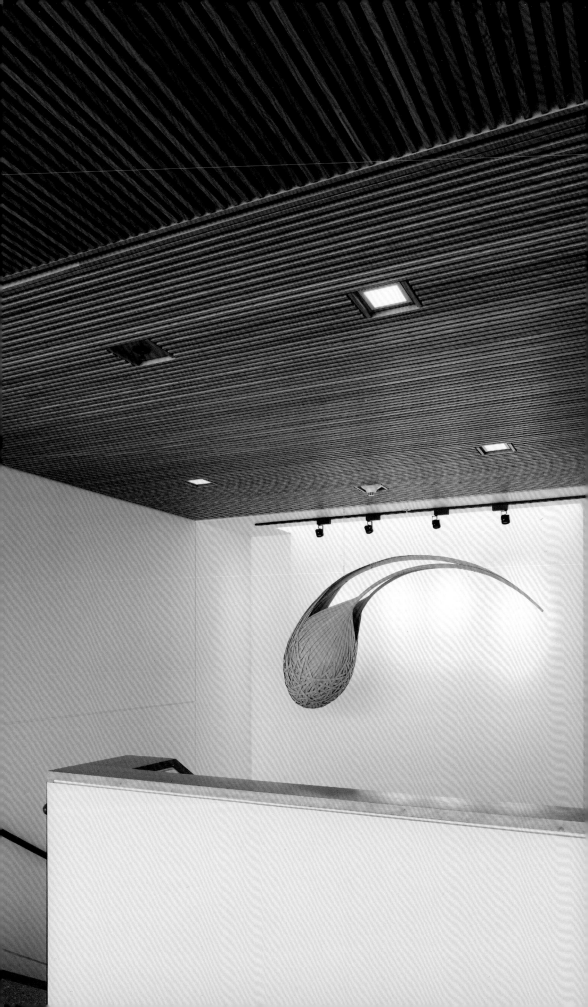

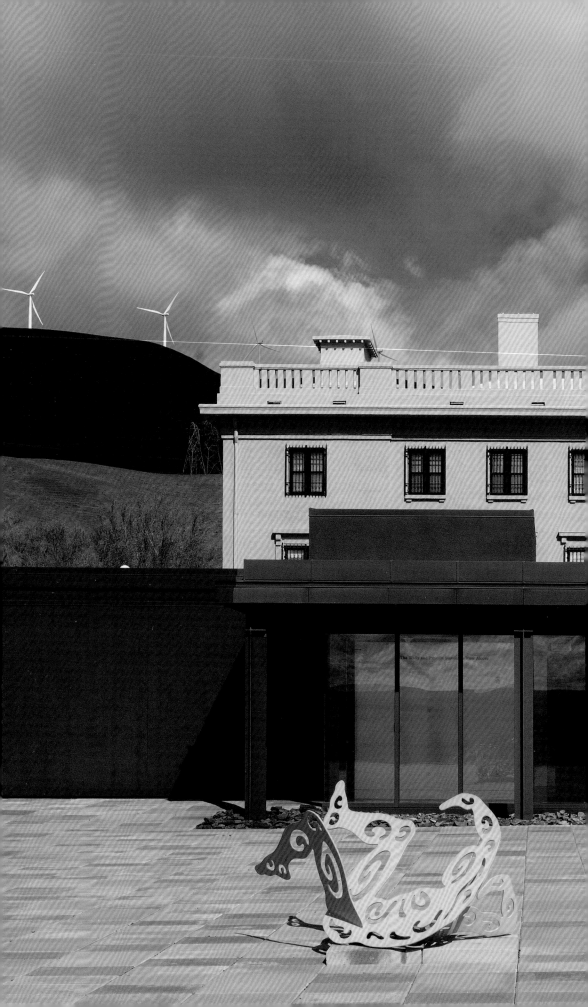

# MARYHILL MUSEUM
## INTRODUCTION

Maryhill Museum of Art is, without question, one of the most unusual and enchanting museums in America. Known throughout the Pacific Northwest, Maryhill Museum stands as a beloved cultural treasure and favorite tourist destination.

But this was not always the case. When *Time* magazine reported on the public opening of Maryhill Museum in its issue of May 20, 1940, its description of the new museum sounded inauspicious:

> "Sam Hill's dream house, standing out among the surrounding sage brush as incongruously as a top hat in a jungle, became a famed landmark. Some said Sam Hill expected to establish a monarchy in the neighboring mountains. Others hinted that he expected his castle to serve as officers' quarters in a future war with invading Japanese forces. To most Washingtonians it was simply 'Sam Hill's Folly.'"

The article ended by calling Maryhill Museum "the world's most isolated art museum." Such ignominious words (not to mention the misleading innuendoes about the key founder's motives) suggest the improbability that a museum of art would exist so far from a metropolitan area. Even today, the closest town to the museum is rural Goldendale, Washington, 13 miles away with a population of 3,500, mostly ranchers and farmers. The museum is separated from the closest urban center—Portland, Oregon—by the Columbia River Gorge, which creates even more of a psychological distance than the 100-mile trip would imply. As one passes east from Portland through the Columbia Gorge, one is embraced by craggy cliffs and dense evergreen forests punctuated by waterfalls and columnar basalt. But as one continues east, the drama of the Gorge segues into endless rolling hills that nearly drop into the Columbia River. The landscape is now arid and the vegetation turns to tumbleweed. Herds of beef cattle, summer brush fires, and the occasional rattlesnake are common sights. It is here, at the east entrance to the Columbia Gorge, that one finds a gem called Maryhill Museum.

The story of how Maryhill Museum began is so inconceivable that it is the Pacific Northwest's best argument that truth is stranger than fiction. That the museum developed at all is due entirely to the friendship of four individuals in the early part of the 20th century: Samuel Hill, Queen Marie of Roumania, Loie Fuller, and Alma de Bretteville Spreckels. These four friends, who lived far apart on two continents, on the surface seem unlikely to have met one another, let alone become trusted confidants. In any case, their friendship formed the legacy of one of the most novel museums in the world.

The museum's founding begins with the dreamer and entrepreneur Samuel Hill, who decided to establish an agricultural

community on the banks of the Columbia River at a spot where, he said, "the sunshine of the east meets the rain of the west." Hill began building a residence there in 1914. When his land company failed, Loie Fuller, an early pioneer of modern dance and the toast of fin de siècle Paris, convinced Hill to turn his unfinished home into a museum of art. In fact, Loie would assist Hill in filling his museum by acquiring works of French artists, most notably her friend the master sculptor Auguste Rodin. Later, in 1926, another of Hill's dear friends, Queen Marie of Roumania, made a historic journey to America for the sole purpose of dedicating Sam Hill's unfinished mansion as a museum of art. Despite Marie's much-celebrated visit, the museum languished for more than a decade, remaining an empty concrete shell of a building with artwork still stored in packing crates. After Hill's death, a third friend, Alma de Bretteville Spreckels, came to the rescue as one of the museum's first trustees and a most generous benefactor. Under Alma Spreckels' shrewd and watchful eye, the museum finally opened its doors to the public on what would have been Samuel Hill's 83rd birthday, May 13, 1940.

If this story has elements of a fairy tale, it is only fitting, for the collections contained in the museum are nothing short of magical. Today the museum houses art and artifacts illustrating the life of Queen Marie of Roumania, a superb collection of sculpture by Auguste Rodin, an art nouveau glass collection, Russian icons, European and American paintings, French fashion mannequins, an encyclopedic survey of Native American basketry representing the major tribes of North America, and a collection of chess sets. Some of these collections, such as the Queen Marie memorabilia and the fashion mannequins, are unique in the strictest sense of the word, because comparable materials do not exist elsewhere.

The seasoned traveler will note that the Unites States is dotted with small and marvelous examples of private homes that have been reincarnated as exhibiting museums. The Hillwood Museum in Washington, D.C., founded by Marjorie Merriweather Post, is one example. The Isabella Stewart Gardner Museum in Boston is another. Characteristically, such museums are filled with artwork collected by the founder, objets d'art chosen with a singular aesthetic vision. Usually these museums in former homes are located in or near a major city. In the case of Maryhill Museum, nothing is typical, and much is extraordinary. The relative geographic isolation is now appreciated for the surrounding natural beauty. Instead of exploring the taste of a single eye, the collections at Maryhill illustrate a tale of uncommon friendship and even adventure. Elucidating an entire era through its breadth and depth, the Maryhill collection—discovered like a diamond in the rough—is startling and evocative. And it is without peer among American museums.

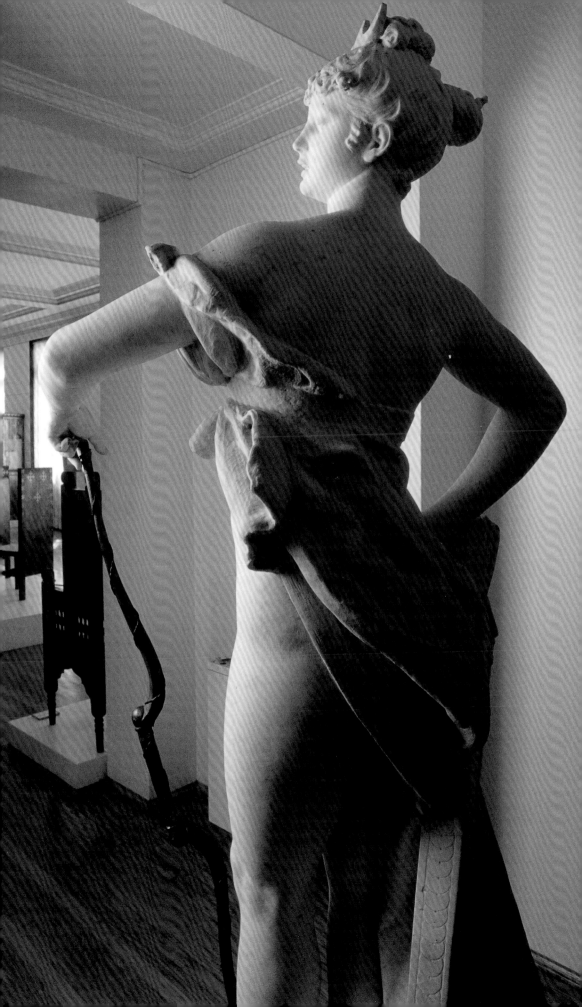

# SAMUEL HILL
## VISIONARY BUILDER

Visionary. Entrepreneur. World traveler. Road and monument builder. Philanthropist. Friend to royalty. These are a few of the descriptions typically applied to Samuel Hill, the principal founder of Maryhill Museum. Hill was a man larger than life, leonine in appearance, with a capacious ability to envision the improbable, then effect progress toward his goal. A complicated man, Sam Hill did not have a very happy personal life; he spent most of his adulthood estranged from his wife and two children. Yet the voids left by his family were filled beyond the brim with projects and prospects that left a legacy of unusual accomplishments.

Samuel Hill was born in 1857 in Deep River, North Carolina, the son of Quaker parents. When Sam was eight, his family moved to Minneapolis, where he grew into a tall, handsome young man. After graduating from Harvard University, Sam began practicing law in Minneapolis and, in 1886, became a law clerk at the Great Northern Railway of James J. Hill (no relation). Within two years, Sam Hill had joined the inner circle of James J. Hill's trusted advisers and had married James J. Hill's eldest daughter, Mary Frances Hill. Soon thereafter, Sam and Mary had two children: a daughter, Mary Mendenhall Hill, born in 1889, and a son, James Nathan B. Hill, born in 1893.

Sam Hill's affiliation with the Great Northern railroad empire set the stage for the future course of his life. The railroad company had extended its line to Seattle in 1893, and Sam Hill was already president of the Seattle Gas and Electric Company, a company owned by Minneapolis investors. By 1902, he had bought land in Seattle to build a home. By then, however, his marriage was strained; his wife, Mary, would never permanently join him in the West.

**Samuel Hill as a young man, c. 1880.**
Photographer unknown.

During his early years as an attorney, Great Northern representative, and businessman, Sam Hill earned his reputation for world travel. Having made more than 50 trips to Europe, nine to Japan, and three to Russia (including a trip on the Trans-Siberian Railway), he adopted a sort of personal trademark: the world globe. In fact, Hill ordered more than two dozen custom-made 32-inch world globes from a Berlin cartographer. These Hill gave to close friends and institutions as gifts. The globes were customized to include the connecting routes of the transcontinental American railroads and the soundings of West Coast harbors to commemorate Hill's business pursuits.

Early on, Hill became a proponent of a cause that would remain a passionate avocation throughout his lifetime: the Good Roads Movement. As the 19th century ended, the road systems throughout the Northwest were not keeping up with the increasing popularity of—and dependence on—the automobile. The Good Roads Movement was initiated by a group of bicyclists, the League of American Wheelmen, but quickly grew as a grassroots political movement to develop better roads and highways for commerce, national defense, and

tourism. Almost as soon as Hill moved to Washington state in 1899, he became the first president of the Washington State Good Roads Association. (He was later named honorary president for life.) The association not only was concerned with the development of roads throughout the state, but also advocated for the development of the Pacific Highway, a north-south transportation artery that would connect Canada to the Columbia River and, eventually, south through Oregon, California, Mexico, and into South America.

Hill's interest in road building was so great that he established a chair of highway engineering—the first in the country—at the University of Washington in 1907. Moreover, he became a passionate campaigner for good roads, lobbying state and federal legislative bodies for funding to research construction methods and build roadways. Hill became well known for his collection of glass negative slides illustrating examples

of favorable roads and road-building techniques, which he presented to countless audiences as he promoted his cause.

By 1907, Hill had purchased 6,000 acres of land along the Columbia River and begun road experimentation there. Bringing in well-known road experts for consultation, Hill tried seven different types of experimental road construction in an effort to determine the proper drainage, gradients, binding materials, and rock to withstand wear and variations in temperature. Totaling 10 miles in length, the experimental roads—the first in the state to be paved—cost Hill more than $100,000. The remnants of Hill's roads that remain today on the Maryhill property are known as the Maryhill Loops. The Maryhill Loops ascend 850 feet in some 4.5 miles in a series of exaggerated hairpin curves, keeping the gradient of ascent low.

Hill's zeal for good roads extended far beyond his own property. He initially lobbied the Washington state legislature for a highway on the northern bank of the Columbia River, a route that would connect his Maryhill property with the north-south artery through Vancouver. Hill had long envisioned a system of highways in the Northwest including a coastal highway, the Pacific Highway, and a route through central Washington and Oregon to California, all united to the north by the east-west axis of a Columbia River route. Beginning in 1906, planning was under way for the North Bank Highway, a road

Inset: **Sam Hill at his Seattle, Washington, residence overlooking Lake Union, c. 1925.**
Photographer unknown.

Right: **This globe clock belonging to Sam Hill has an intricate mechanism that not only measures time, but also rotates the miniature globe through diurnal and annual cycles. 10 x 14 x 21 inches.**

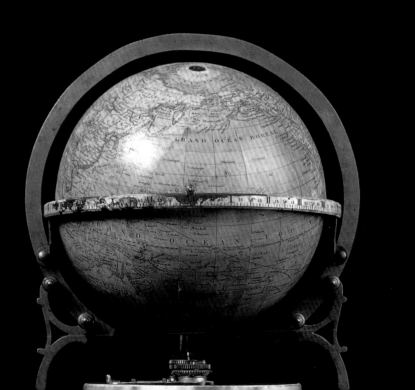

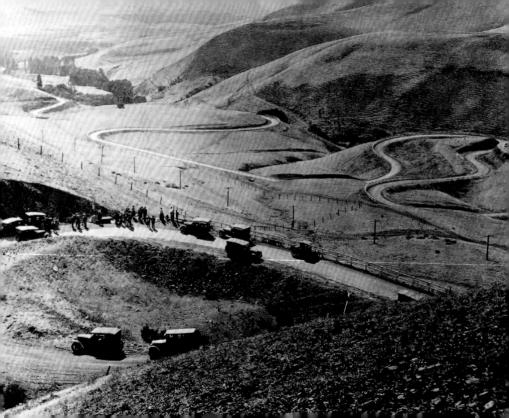

linking Washougal and Goldendale, Washington. Each county along the route—Clark, Skamania, and Klickitat—was to be responsible for building the highway within its boundaries; construction funds were appropriated by the state, and use of convict labor would help keep costs down. Eventually, the state cut back funding for highway construction and the east-west corridor project came to a standstill. With typical tenacity and foresight, Sam Hill looked to Oregon to help him realize the dream of a highway through the Columbia Gorge.

Being particularly passionate about the project of building the Columbia River Highway, Hill went to work in earnest to convince Oregonians that a road would benefit commerce and tourism. Early in 1913, Sam organized an excursion for

*The Maryhill Loops Road was used until 1948, when a more modern road was built on the opposite side of the canyon. The Loops are now used for sports car hill climb races and pedestrian use.*

Oregon's Governor Oswald West and the entire legislature to travel to Maryhill via special train to inspect his experimental roads and view his now famous slides of road building. Soon prominent Oregonians joined Sam's fervent cause: Julius Meier, owner of the Meier & Frank department store in Portland; Simon Benson, millionaire lumberman; John Yeon, a Canadian lumber baron; and C.S. Jackson, publisher of the *Oregon Journal* newspaper, committed their support. John Yeon contributed two years of volunteer service as an unpaid roadmaster; property owners along the Columbia donated land needed for the road and parks along the way.

Once funding for the highway was secure, Sam Hill brought in the experienced Samuel Lancaster as chief engineer for the project. There was no question that building the highway would be a technological feat; it had been said that "You can't *survey* a road along the Columbia River, let alone *build* one." Sam Hill had met Samuel Lancaster earlier through their mutual interest in the Good Roads Movement. Lancaster's expertise was well known from his years as city engineer for Jackson, Tennessee, where he developed a system of hard-surfaced roads. Already his close ally in a common cause, Hill had hired Lancaster to come to Washington to work on his own Maryhill property roads. (Lancaster also became the first professor of highway engineering at the University of Wash-

Inset: **An example of experimental asphalt used on the Maryhill Loops Road, 8.5 x 3.5 x 5.5 inches.**

Left: **Maryhill's historic Loops Road, photograph taken during the Oregon state legislature's visit in 1913.** Photographer unknown.

Overleaf: **Crown Point on the Columbia River Highway, c. 1915.** Photograph by Albert Barnes from the original glass negative in the Samuel Hill collection.

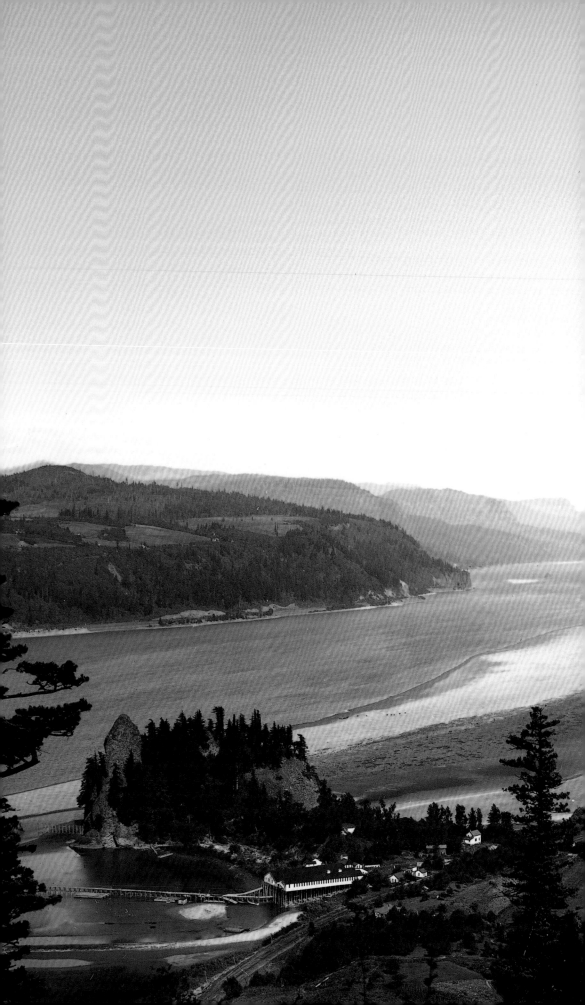

ington.) Along with Lancaster's prowess as an engineer came an aesthetic benefit. Lancaster became known for his sensitivity toward the natural environment and his deft ability to develop the road system with as little harm to the surroundings as possible. Lancaster later commented on his determination ". . . that none of this wild beauty should be marred where it could be prevented. The highway was so built that not one tree was felled, not one fern crushed, unnecessarily."

Sam Hill's role in the Columbia River Highway was as catalyst. He had the entire enterprise sketched out vividly in his mind, bringing together those of influence and skill to spur the project to completion. The Columbia River Highway was completed in just two years, from 1913 to 1915. The Columbia Gorge portion of the highway was 48 miles long. Construction of the highway was as technically advanced as possible for the time, using reinforced concrete in the 17 arched bridges and viaducts designed to fit naturally within the steep slopes and

cliffs of the Gorge. The retaining walls were made of dry masonry, reminiscent of those viewed by Hill and Lancaster on a 1908 trip to Europe. Italian masons who had worked on Sam Hill's home in Seattle were employed to bring old world charm to the technological wonder. The highway was officially dedicated on June 7, 1916, at a ceremony at Multnomah Falls that coincided with Portland's annual Rose Festival.

If the Columbia River Highway was Sam Hill's most cherished civic dream, his land company and intended residence at Maryhill were his private monuments. In 1907 Sam bought 6,000 acres of land in Klickitat County, near the small town of Columbus, Washington, located on the Columbia River about 100 miles east of Vancouver. Sam was already familiar with the terrain along the Columbia because of the Great Northern Railway's projected route between Vancouver and Spokane. His close friend and law partner, Charles Babcock, had been a land purchase agent for the Great Northern and had mapped

Inset: **Mitchell Point on the Columbia River Highway, c. 1915.** Photograph courtesy of the Oregon Historical Society, negative number 3587 #271-N.

Right: **Multnomah Falls on the Columbia River Highway, c. 1915.** Photograph by Albert Barnes from the original glass negative in the Samuel Hill collection.

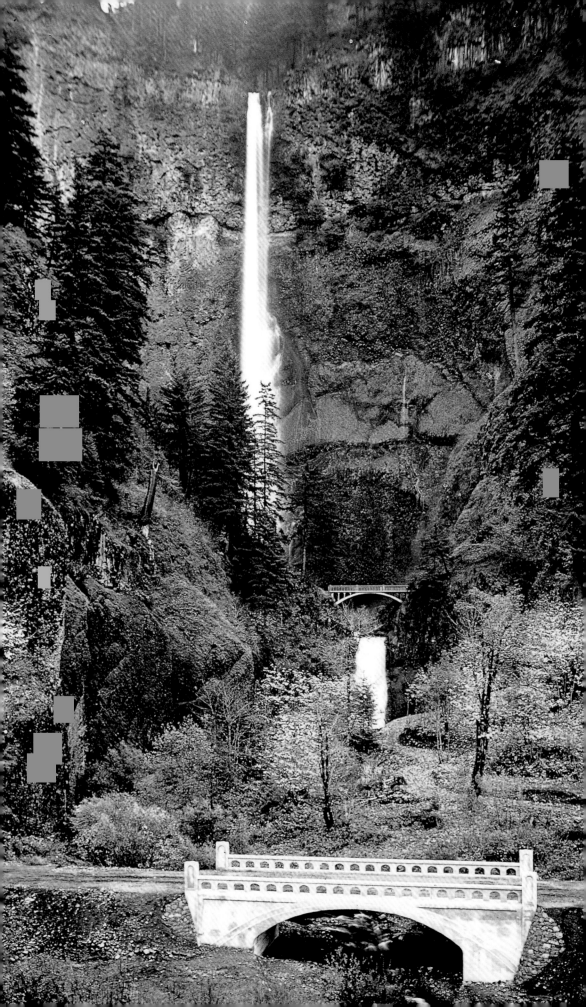

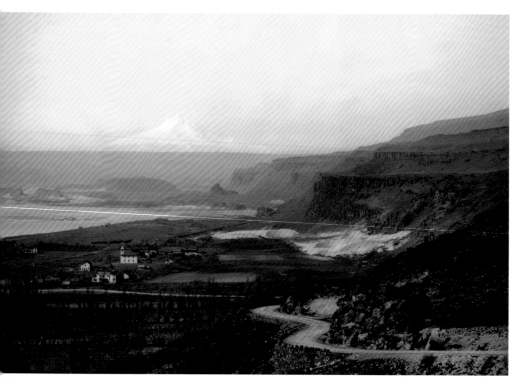

out much of Klickitat County. Hill became fascinated with the geography of the area, and the fact that the rain shadow on the west side of the Cascades quickly gave way to the sunny, semi-desert landscape on the east side. Hill decided to use his land to develop an agricultural community, using the slogan, "Where the rain and sunshine meet," hoping to lure buyers with the prospect of prosperous farms, orchards, and livestock. Initially, he hoped that his townsite would attract Quaker settlers.

Naming his land company Maryhill, in honor of his wife and daughter, Sam set about building a town. He built a stone store and post office, the Maryhill Land Company office and weather station, an inn (the St. James, later, the Meadowlark Inn), a Quaker church, a stable and blacksmith's shop, a garage, and housing for men working on his experimental roads. He also built a bungalow for his daughter, calling it "Miss Mary's Cottage," which was finished by July 1910. Mary Mendenhall Hill visited her father there during the summers, along with her nurse companion, until 1916.

To more conveniently oversee his land company, Hill began building a ranch house at Maryhill. Sited at the west end of his property, the mansion was to be built on a high ledge, overlooking the river with commanding views of Mount Hood to the west, the wheat fields of Oregon to the south, the flowing Columbia River to the east and, to the north, the mas-

Sam Hill's daughter, Mary Mendenhall Hill, and companion at Maryhill, about 1910. The Quaker meeting house built by Hill on his property is in the background. Photographer unknown.

sive, barren Klickitat hills, which are covered with wildflowers in the spring. He chose the architectural firm of Hornblower & Marshall of Washington, D.C. (which had also planned his Seattle home), to design his residence in a style appropriate for the grand entertaining Hill foresaw. Construction began in 1914. Typical of Hill's interest in experimental building materials, the mansion was built of poured concrete with thick walls reinforced by steel.

Hill's interest in automobile travel was evident in one of the most striking architectural features of the mansion. The core of the house is 60 by 93 feet, but on its east and west ends, long ramps lead up to massive double door entrances, extending the length of the building to about 400 feet. At the top of each ramp is a circular turnaround. Sam planned that his guests could drive into one of the two garages built underneath the ramps (each garage could hold 24 automobiles), then take an electric elevator to the main floor of the mansion. Or, more dramatically, the car could be driven straight up one ramp, through the double doors, and discharge passengers in the great reception hall on the south side of the house, then exit the other side and down the opposite ramp.

The ramps were not the only extravagance planned for the home. Hill intended the main floor for his own use, using the north side of the house for a library, den, dining room, serving room, and the master bedroom. The third floor was to be divided

"I have planned it for a good, comfortable and substantial farmhouse. Here I can let the world wag as it will. My cold storage plant will keep my meats and farm products in good shape. It is large enough to have a few friends drop in and take potluck with me. I can keep them warm in winter and cool in summer. On the roof we will have our outdoor bedrooms throughout the summer months, and we can look up and watch the wheeling constellations swing across the night sky, or look down on the sea-seeking Columbia or at Mt. Hood in all its varying moods. . . . I expect this house to be here for a thousand years after I am gone."

*Sam Hill*

into eight bedroom suites for guests, each with its own bathroom. A warming oven was to be installed in the wall of the third floor, so that each guest could rise at leisure to a warm breakfast. The lower floor, or the basement, was to contain the kitchen, laundry, furnace and boilers, pantry and other storage, refrigeration, and five rooms for the service staff. The furnace could burn coal, oil, or wood, and, although the nearest source of electricity in 1914 was the town of Maryhill, over three miles away, Hill wired his mansion for eventual service.

Despite every effort to ensure that his investment reaped financial rewards, Sam Hill's Maryhill Land Company was a dismal failure. Besides Hill's friend, Charles Babcock, and one Maryhill Land Company employee, only one other family purchased land and built a house. There seemed to be no question that the land could yield great quantities of produce—

peaches and grapes in particular. There was even a time when the ranch supplied fruits and vegetables for the Spokane, Portland & Seattle Railway. But lack of irrigation, transportation challenges, and the unrelenting chill of the east wind on the exposed property remained insurmountable obstacles to the land company's success. Hill even tried his hand at converting the land into a beef cattle ranch. Ultimately, Hill's expenditures on his planned community and ranch house exceeded the income from the land company.

By 1917 construction on the Maryhill residence stopped. Hill's financial straits, his other business distractions, and the country's involvement in World War I seemed to doom Sam Hill's plan to live as a resident in his own community. What would become of the strikingly stark concrete manse?

In 1917, Sam's friend, the early modern dancer Loie Fuller, convinced him to turn his mansion into a museum of art, art that Loie herself would help select and obtain through her close association with famed artists in France, most notably the sculptor Auguste Rodin. Persuaded by her arguments but slow to take the next step, Hill submitted the articles of incorporation for the "Maryhill Museum of Fine Arts" to the Klickitat County clerk in 1923. He shipped objects from his own collection of paintings, Native American art, and personal mementos to the still half-finished structure. In 1926 Hill invited

Inset: **Sam Hill's Maryhill mansion under construction, the third story ready to be poured, December 23, 1914. From an album belonging to Sam Hill.**

Right: **The long ramps at either end of the museum were designed so that automobiles could drive up the incline and discharge guests in the grand entry hall.**

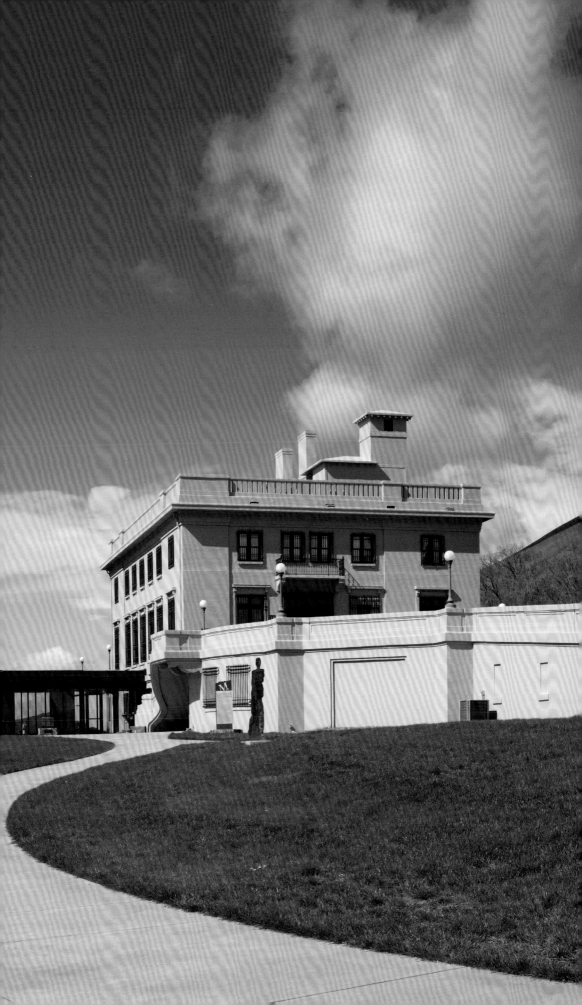

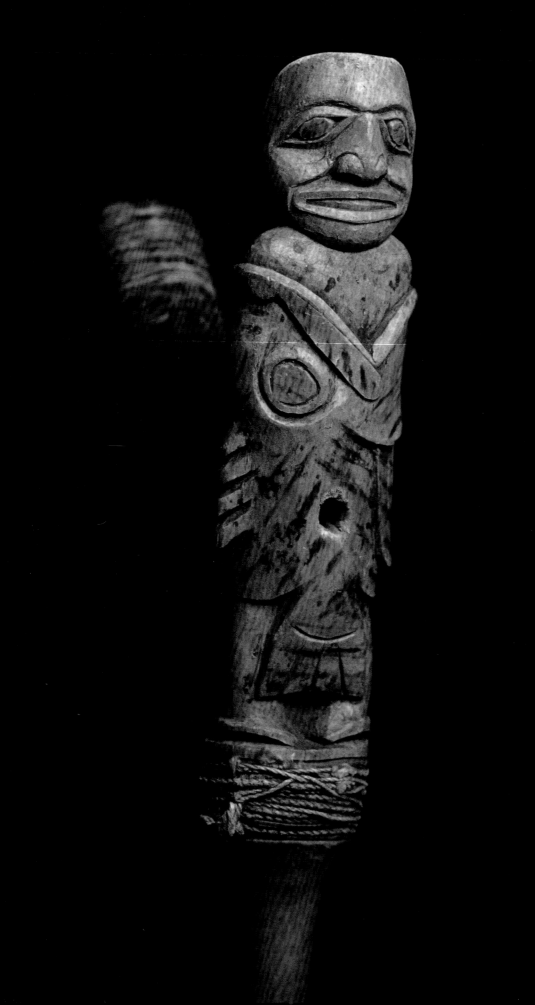

his close friend, Queen Marie of Roumania, to visit Maryhill and dedicate his museum of art. It must have been an astonishing sight for Queen Marie, who had traveled across the country with her daughter, Princess Ileana, and her son, Prince Nicolas, to arrive at the museum and find it an empty concrete shell—especially since she had brought along numerous boxes of gifts from Roumania to add to the museum's collection. As it turned out, the mansion would not be completed until long after Sam's death, and it would be up to another of his friends, Alma de Bretteville Spreckels, to realize the dream of Maryhill as a museum of art.

The civic pride and unflagging ambition one sees in Sam Hill's interest in the Good Roads Movement, the building of the Columbia River Highway, and his intended empire at Maryhill, Washington, all foreshadow another of Hill's curious penchants. A lifelong pacifist, Hill planned and funded two monuments dedicated to peace. This was an altruistic quest to commemorate ideas he held dear, rather than to immortalize

*Sam Hill was fascinated by the indigenous history of the Pacific Northwest and collected Native American artifacts and Edward S. Curtis photographs. He was a friend of Chief Joseph of the Nez Percé tribe and aided the Washington Historical Society in erecting a monument to Chief Joseph at Nespelem, Washington. Chief Joseph's successor, Yellow Bull, adopted Sam into the tribe and gave him the name Wya-Tana-Toowa-Tykt, meaning "Necklace of Lightning."*

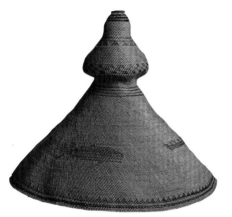

his own extraordinary life. The first of Hill's public structures was built at Blaine, Washington, on the Canadian border. On July 4, 1915, Sam Hill led a celebration there commemorating a century of peace between Canada and the United States. By July 1920, he began construction of a monument—a Peace Portal—that was supposed to be located near the international highway connecting the two countries. Finished in 1921, the International Peace Arch was sited so that one side is on Canadian soil, while the other rests in the United States. Built of reinforced concrete, the white Doric arch is inscribed on the American side "Children of a Common Mother," and on the Canadian side "Brethren Dwelling Together in Unity." Hill believed the idea of healthy international relations and the theme of good roads connecting far-flung destinations were worthy of commemoration.

Hill's more curious monument is Stonehenge, a memorial to the men of Klickitat County who lost their lives in World War I. By the time the altar stone in the center of the Stonehenge mon-

Inset: **Native American Whaler's Hat made by Ellen Curley (Nuu-chah-nulth, formerly Nootka-Makah), c. 1900-1910, spruce root, cedar bark, and surf grasses, 14 inches diameter x 13 inches. Gift of Samuel Hill.**

Left: **Halibut Fishing Hook (Haida), late 19th century, wood and metal, 2.25 x 5.5 x 11.25 inches. Anonymous donor.**

*During Hill's lifetime, the original Salisbury Plains Stonehenge was thought to be a site of human sacrifice. Thus, the ancient ruins seemed an appropriate symbol for those lost to war. As Sam said, "it seems fitting that this sacrifice which we have been called on to make to the war god of the heathen should be fittingly remembered in some permanent way."*

ument was dedicated on July 4, 1918, three soldiers from the county had died; eventually nine more were commemorated.

Sam Hill's Stonehenge was designed as a conjectural model of what the English Stonehenge was thought to have looked like before the centuries left it in ruin. Sited on a bluff overlooking the Columbia River, and in the heart of Sam's intended town of Maryhill, the monument was made of poured concrete to the same scale as the real Stonehenge, the forms lined with crumpled tin to simulate hand-hewn prehistoric stones. The outer circle consists of 30 sarsen "stones," with an inner circle of 30 smaller "stones." In the center lies the altar "stone," measuring six by 18 feet and standing three feet high. Surrounding the altar "stone" are two sets of "stones" set in a horseshoe pattern. Within the horseshoe pattern are trilithon "stones," which create monumental archways in incremental heights; the tallest of these archways reaches 24.5 feet. The

Maryhill Stonehenge monument was finally finished in 1929.

In January 1931, Sam Hill was en route to address the Oregon legislature on behalf of his favorite cause, good roads, when he became ill with acute abdominal pain. Less than three weeks later, on February 26, Hill died at the age of 73 years. Sam had been asked by a reporter for the *Oregonian* newspaper where he wanted to be buried when he died. His response: "Standing on the bluff in front of my place at Maryhill and looking down on the canyon of the Columbia, you will see a mass of jagged rocks, nature's great upheaval. Here on the bluff in time to come, I hope there will be over my ashes a bronze tablet bearing this inscription: 'Samuel Hill: amid nature's great unrest, he sought rest.'" In accordance with these wishes, his body was cremated and the ashes placed in a crypt, just below the Stonehenge monument.

Inset: **The Peace Portal in Blaine, Washington,** probably at the dedication in 1921. Photograph by Ashael Curtis.

Right: **Sam Hill's Stonehenge is located off Highway 14, three miles east of Maryhill Museum.**

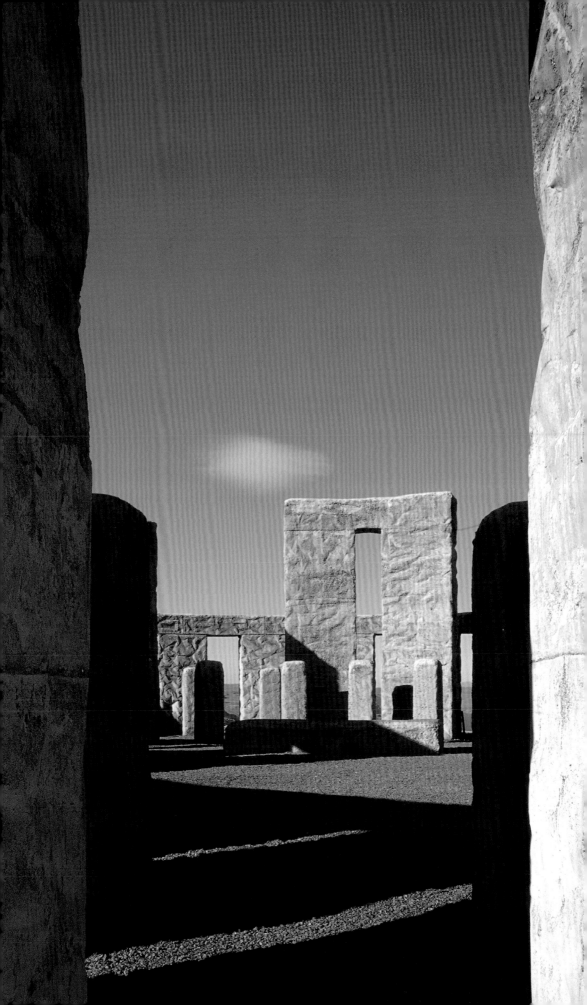

QUEEN MARIE OF ROUMANIA
ROYAL FRIEND AND BENEFACTOR

When Sam Hill decided to turn his mansion into a museum of art, he called upon his dear friend, Queen Marie of Roumania, to dedicate the structure. Sam could hardly have chosen a more impressive celebrity to inaugurate his museum, for Queen Marie was peerless in her stature as a beautiful and accomplished sovereign. Queen Marie was arguably the first member of royalty to attain international celebrity; at one point, she was named the most influential woman in the world, along with Charles Lindbergh, the most influential man.

Marie was born in 1875 into the two most powerful royal houses of Europe. The granddaughter of Queen Victoria of England on her father's side and Tsar Alexander II of Russia on her mother's side, Marie spent her childhood between Windsor Castle in Britain and the Winter Palace in Russia. Her marriage to Ferdinand, Crown Prince of Roumania, was arranged by her mother and sent Marie to a country she had barely heard of, let alone ever been to. Nonetheless, Marie learned to passionately embrace her adopted home.

As crown princess of Roumania, and later queen, Marie had six children and lived in several royal residences throughout Roumania, including Castle Bran in Transylvania, the fairy-tale castle that provided inspiration for Bram Stoker's 1897 horror novel *Dracula*. Her marriage thrust her into a country as unfamiliar and exotic as Marie could find in pre–World War I Europe and, despite a lonely existence and an unhappy marriage, she grew to love Roumania. The colorful peasants in traditional dress, the folklore, and the traditional folk crafts appealed to Marie's dramatic inclinations. Before long, Marie was the beloved matriarch of her new kingdom.

As a child in Victorian England, Marie had been well trained for a leisurely but productive royal life. She was taught to draw, paint, and do handwork, pursuits that came in handy during her lonely early years in Bucharest. She became an accomplished painter, especially of flower still lifes. She was also a prolific writer, penning more than 15 books in her lifetime, including several autobiographical accounts and many stories for children. Fascinated by Roumanian folk craft and with a natural taste for things medieval or Byzantine, she employed woodcrafters to carry out her own designs for ornately carved and gilded furniture, many examples of which are in the Maryhill Museum collection. In her own typically theatrical fashion, the queen adopted the lily as her personal symbol and repeatedly used the flower throughout her esoteric designs.

During World War I, Marie's political and social influence over her country became increasingly evident. Through Marie's diplomatic pressuring of her own royal family and its advisers, Roumania joined the Allied Forces despite her husband's ties to Austria-Hungary. World War I was devastating for Roumania; under German occupation the royal family had been forced to flee Bucharest and spend the war years in Jassy

*When Queen Marie visited Maryhill Museum in 1926, she brought with her a number of gifts and mementos, including jewelry given to her by her grandmother, Queen Victoria of England. This watch was a gift from Queen Victoria to Queen Marie's daughter, Mignon. 1.75 x 4 inches.*

near the Russian border. Nonetheless, Marie became a tireless and impassioned minister to her compatriots, turning her palace into a 120-bed hospital, nursing wounded soldiers herself, and traveling throughout Roumania to be of encouragement and aid.

Sam Hill reported that he had met Marie as Crown Princess of Roumania in 1893, the year of her marriage to Ferdinand, when Hill was in Europe to sell Great Northern Railway bonds to members of royalty. But it was later, and through his collaborations with Loie Fuller and Alma Spreckels to send war relief to Roumania, that the relationship developed into one of deep mutual admiration and trust.

From the start of World War I, Loie Fuller had busied herself with war relief, marshalling influential friends to help raise funds for war-torn Europe. Loie not only made compelling pleas to the American embassy in Paris to convince the

Americans to issue a government loan for Roumania, she also traveled to America to campaign for this cause. Loie organized the American National Committee for Roumanian Relief and lobbied the American Red Cross for money, food, and clothing. At one point Loie telegraphed Marie that her national organization was sending $700,000 to Roumania. Both Sam Hill and Alma Spreckels joined Loie's campaign and labored to assist Roumania (along with France and Belgium). In 1919, Sam Hill traveled to Roumania, taking passage on a ship carrying relief supplies to Constantza, Roumania; he later worked with the Herbert Hoover Food Administration mission to forward relief supplies to the Roumanians.

Sam Hill, Loie Fuller, and Alma Spreckels demonstrated their dedication to Queen Marie through her darkest hours of the war, performing deeds that won the queen's heart and lifelong gratitude. In 1926, when Sam Hill asked for a favor in return—for Queen Marie to venture to the Wild West of the

Inset: **Portrait of Queen Marie with Castle Bran in the distance, her beloved home in Transylvania.** Photographer unknown.

Right: **Signed aquatint of one of Queen Marie's watercolor still life paintings, typical of her artistic style, 21.75 x 22.75 inches (framed).**

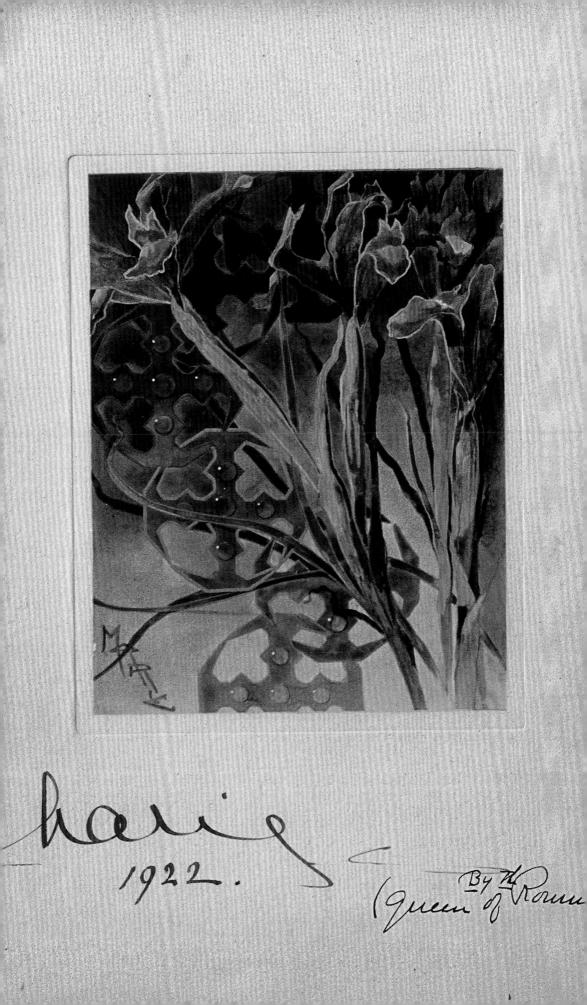

Marie

1922.

By the

(Queen of Roum

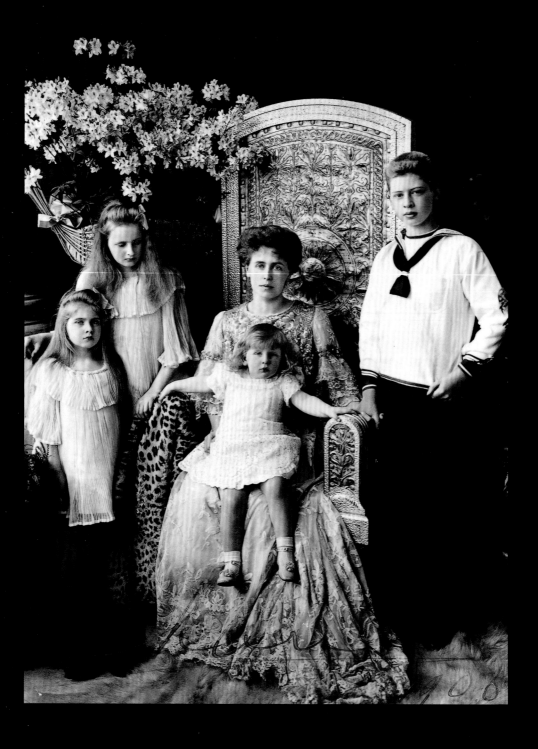

United States to dedicate his mansion as a museum of art—Queen Marie could not refuse.

Only once before had members of royalty visited the United States. (In 1919 King Albert and Queen Elizabeth of Belgium had returned a visit to President Woodrow Wilson.) For royalty-starved Americans, Marie's 50-day tour caused a media sensation. She traveled with her daughter, Princess Ileana, then 17, and her son, Prince Nicolas, age 23, starting their journey in Paris, where Marie had several couture houses preparing wardrobes for herself and her daughter. From there the queen and her entourage of 17 people boarded the S.S. *Leviathan,* bound for New York. She arrived on October 18, 1926, to a ticker-tape parade. From New York City the queen went to Washington, D.C., for an official visit with President and Mrs. Calvin Coolidge, then back to New York to attend a dance performance of Loie Fuller's *The Lily of Life*, an adaptation of Marie's own fairy tale.

On October 25 the queen's train, the *Royal Rumanian,* headed west from New York City, making stops at West Point, Niagara Falls, Buffalo, Toronto, Montreal, Ottawa, and Winnipeg. The train stopped in Minneapolis for a reception at the home of Sam Hill's brother-in-law and chairman of the board of the Great Northern. From there the *Royal Rumanian* stopped in Mandan, South Dakota, where a delegation of Sioux Indians met the train. Red Tomahawk, the chief who had killed Sitting Bull, honored the queen with a war bonnet of eagle feathers and the title "The Woman Who Was Waited For."

Sam Hill, Loie Fuller, and Alma Spreckels joined their friend the queen in Spokane for the last leg of the journey to Maryhill. When the queen arrived at Maryhill, Washington, on that frosty morning of November 3, she must have been dumbfounded to see the mansion, intended to house a great art collection, but in reality a desolate, unfinished shell. Residents of Goldendale and Sam's supporters from Portland had done their best to prepare the museum for its royal visitor. Bunting in Roumanian colors—red, yellow, and blue—festooned the interior; pine boughs and chrysanthemums were abundantly arranged and the American and Roumanian flags stood behind a throne for the queen. Even a red carpet, obtained after a "frantic search . . . from a hotel back stairway in Portland" had been rolled out for the queen's entrance. (The same carpet was used at each site throughout the Pacific Northwest portion of Marie's journey; it was quickly rolled up after each use and rushed to the next location.)

A crowd of some 2,000 had gathered around the museum awaiting Marie's appearance. Four hundred schoolchildren had been brought by trucks from the Goldendale area, and a caravan of people from Portland had made the trip. The queen began by releasing carrier pigeons to deliver messages to 10 cities. Then she rose to deliver a gracious address, sparing her friend Sam Hill any embarrassment over his unfinished man-

Left: **Queen Marie, seated in her silver-gilt audience chair, surrounded by four of her children, from left: Marie ("Mignon"), Elisabeth, Nicolas, and Carol II.** Photographer unknown.

Below: **Silver-gilt cabinet designed and used by Queen Marie, c. 1900-1910. Marie considered the lily to be her symbolic flower and used it repeatedly in her designs. 20.75 x 14.75 x 78.25 inches. Gift of Alma de Bretteville Spreckels.**

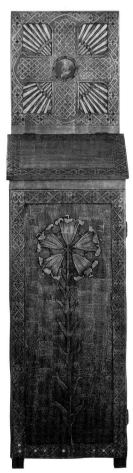

sion and paying tribute to her friendship with Loie Fuller:

"As I stand here today in this curious and interesting building, I would like to explain why I came. There is much more than concrete in this structure. There is a dream built into this place—a dream for today and especially for tomorrow. There are great dreamers and there are great workers in the world. When a dreamer is also a worker, he is working for today and for tomorrow as well. For he is building for those who come after us.

"Sam Hill is my friend. He is not only a dreamer but he is a worker. Samuel Hill once gave me his hand and said that if there were anything on earth that I needed, I had only to ask. Some may even scoff, for they do not understand. But I have understood. So when Samuel Hill asked me to come overseas to this house built in the wilderness, I came with love and understanding. Samuel Hill knows why I came, and I am not going to give any other explanation. Sometimes the things dreamers do seem incompre-

hensible to others, and the world wonders why dreamers do not see the way others do.

"Some have wondered at the friendship of a queen for a woman whom some would call lowly. That woman is Loie Fuller. Her name has often been slighted. That woman stood by me when my back was to the wall. That woman gave me her life in my hour of need. She went all over America getting aid for my people. This has almost been forgotten by the rest of you, but I could no longer be silent. In this democracy, there should be no gap between the high and the lowly. As woman to woman, I wish that there would be no doubt in any heart that that woman gave me hope. Samuel Hill knows this."

Marie then described the gifts she had brought with her for the museum: "They are simple gifts, made by simple hands; embroideries and handiwork in wood and metals." She ended by addressing her host, "Mr. Hill, I would like very much to shake your hand." Sam Hill grasped Marie's hand and kissed it; with that, the crowd erupted into applause.

From Maryhill, Marie's train crossed the Columbia River,

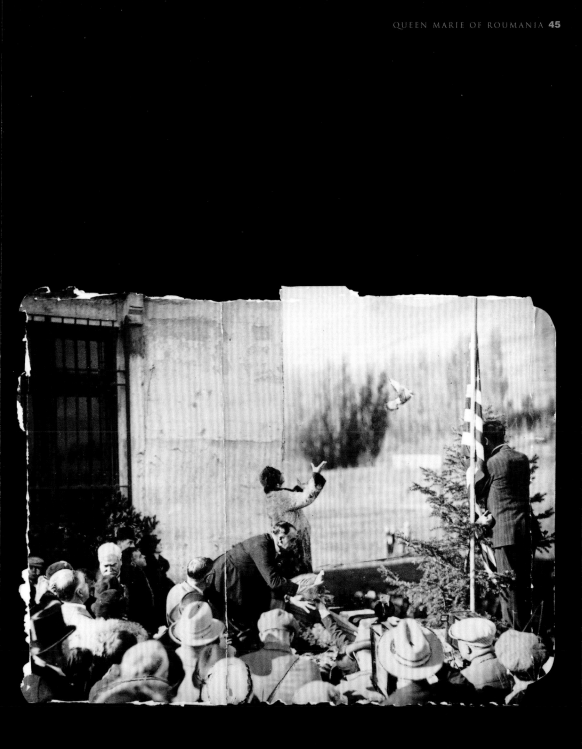

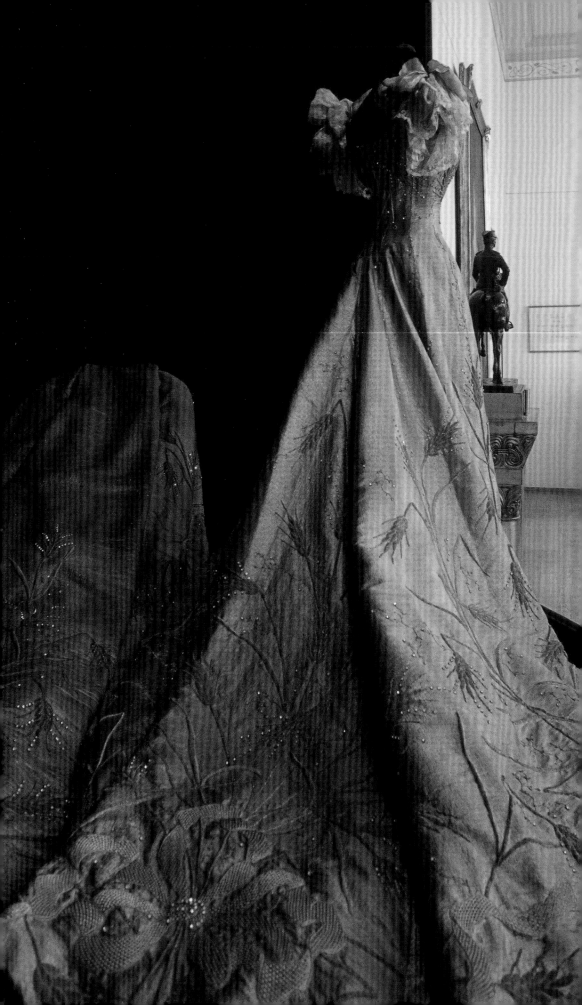

where she was met by the governor of Oregon and taken to Portland, stopping at Vista House on the Columbia River Highway. In Portland Marie made a stop to visit the Shrine Hospital for Crippled Children before being welcomed by a newly formed "Roumania Society" at the Multnomah Hotel. That evening the queen and her party enjoyed the horse show of the Pacific International Livestock Exhibition, then the next day departed for Seattle (stopping in Longview to see the world's largest sawmill). Marie graciously rededicated Sam's Peace Portal in Blaine, Washington, attended ceremonies in Vancouver, British Columbia, then returned to Seattle for a farewell dinner held at Sam's home. By November 24, Marie and her retinue were on board the *Berengaria*, heading for Paris. Marie was eager to return to Roumania, where the king, she had learned, was dying of cancer. But before leaving, she made a final broadcast to the people of America, saying that she hoped she would live "in the hearts of those I have learned to love. . . . This time America has seen me; the next time I intend to see America."

But Queen Marie was never to return to the United States.

*For Queen Marie's coronation she asked that all royal women in her procession wear gold, and all others wear mauve and silver. "I want nothing modern that another queen might have," she said. "Let mine be all medieval."*

Within the next year, King Ferdinand died and Marie withdrew from her very public life. She died in 1938 at the age of 63 in Peles Castle in Sinaia, high in the Carpathian Mountains.

While the museum Marie dedicated in 1926 was not to open until 1940, the gifts she carried to Maryhill for the museum, and the objects she gave to Alma Spreckels—who in turn donated them to the museum—are among the most intriguing of the Maryhill collection.

One of the most enchanting objects in the Queen Marie collection is the gown worn by Queen Marie to the coronation of her cousin, Tsar Nicholas II of Russia, in 1896 and also, reputedly, to the coronation of King Edward VII of England in 1902. The dress has a low-cut, sleeveless bodice and a skirt made up of nine panels. Heavily boned, the bodice was cinched by a back drawstring. Lace frills and gauze bows adorn each shoulder, and the dress would have been worn with arm-length evening gloves. The queen would also have worn her Order of Office on the left front side, with a ribbon extended over her shoulder. The train, attached to the bustle with two tiny hooks, extends several feet behind the dress; at

Inset: **This bracelet, made of Queen Victoria's hair and mounted in gold, was given to Queen Victoria's mother in memory of the births of Queen Victoria's four oldest children: Victoria (later Empress Frederick), Albert (later King Edward VII), Alice (later Grand Duchess of Hesse), and Alfred (later Duke of Edinburgh, Queen Marie's father). In the small clasp are tiny locks of each child's hair. 6 inches diameter x .5 inches. Gift of Queen Marie.**

Left: **Queen Marie's gown and train, worn to the coronations of her cousin Tsar Nicholas II of Russia in 1896 and her uncle King Edward VII of England in 1902. Gown: 65 x 36 x 54 inches; gift of Queen Marie. Train: 100 x 156 inches; gift of Alma de Bretteville Spreckels.**

the edges of the train are small silk handles, meant for the queen's attendants to assist in carrying the weight of the train.

The dress and train are made of gold lamé fabric, woven of silk and metallic threads. A crocodile skin pattern is stamped, or crimped, into the fabric and the dress and train are covered in embroidery, much of it raised and padded. The embroidery features shafts of wheat and bows sewn in a basketweave stitch.

A replica of the queen's coronation crown is another example of Marie's royal regalia at Maryhill Museum. The original crown was made for the October 15, 1922, coronation of King Ferdinand and Queen Marie. While King Ferdinand wore a

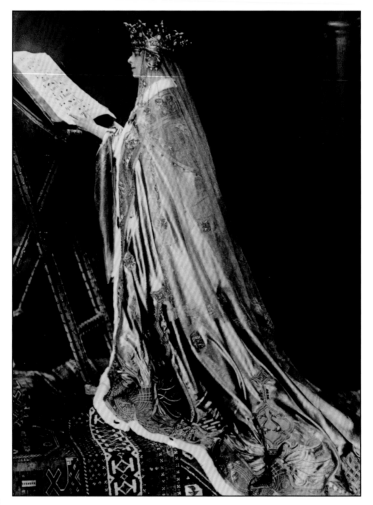

Inset: **Queen Marie in her coronation robe, 1922.** Photographer unknown.

Right: **Queen Marie's coronation crown, Falize Frères of Paris, 1923, silver-gilt with garnets, peridots, turquoise, and moonstones, 9.25 inches diameter x 8.25 inches, pendulae are 10.75 inches long. Gift of Alma de Bretteville Spreckels.**

crown of iron (cast from Turkish guns, symbolizing Roumania's freedom from the Turks at the end of the Russo-Turkish War) previously worn by his uncle King Carol, Marie commissioned a dramatic and curiously medieval-looking crown from the French jewelers and goldsmiths Falize Frères. The design Marie chose for her crown was based on that of Despina Doanna, the wife of a 16th-century prince of Wallachia, a region of Roumania.

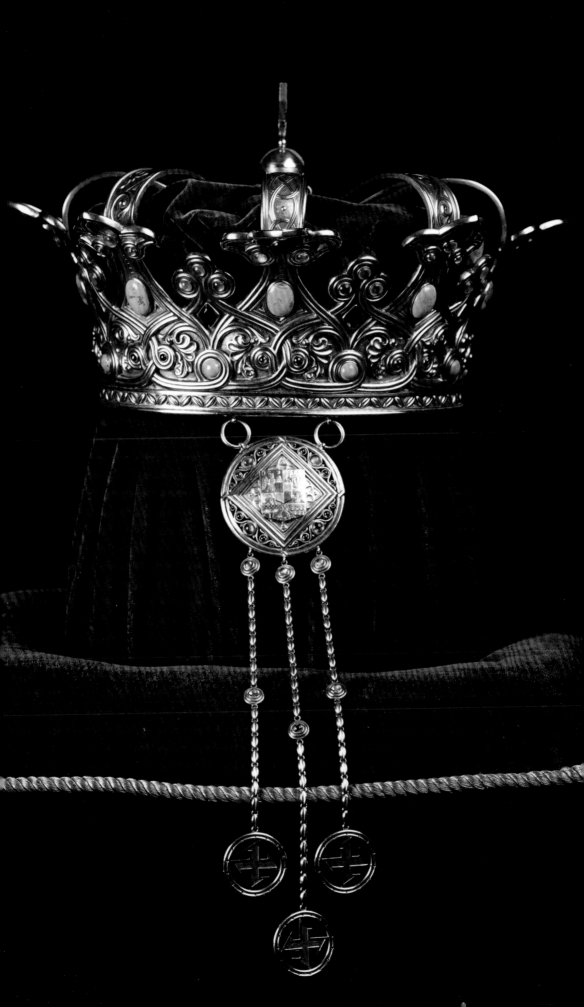

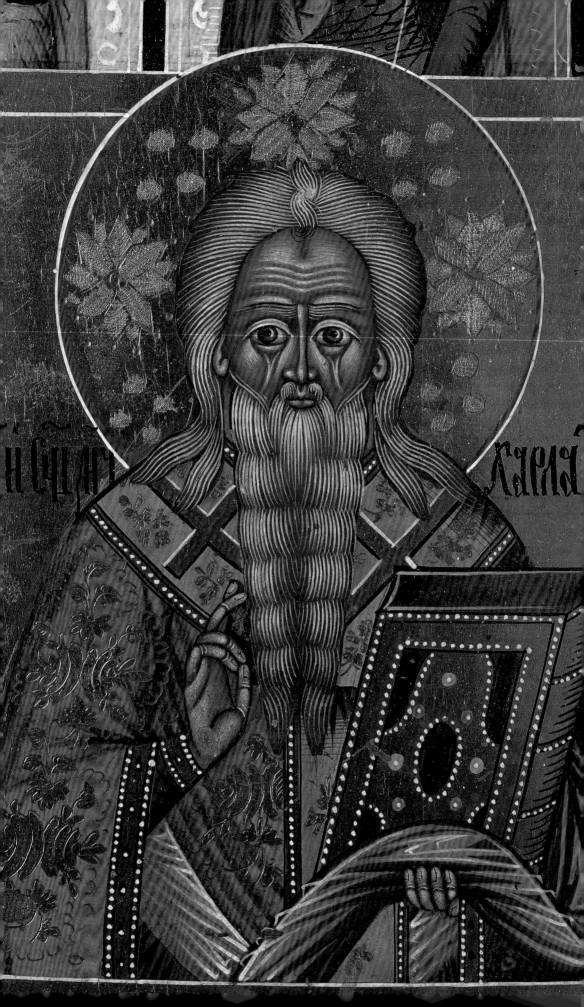

The unusual pendulae, which hang from each side of the crown to cover the queen's ears, are copied from Byzantine head ornaments. The circular medallions suspended over the ears bear the arms of the king and queen. At the top of the crown, and at the ends of the gold strands of wheat, are cross forms that had particular significance to Marie. She reportedly found a cross of this shape at a spot on the ground where her horse mysteriously fell three times; thenceforth this cross became another of her personal symbols. The crown is set with garnets, peridots, turquoise, and moonstones. The Maryhill twin was commissioned from Falize Frères in 1923 by Alma Spreckels, who had intended to establish a "Roumanian Room" at the California Palace of the Legion of Honor but later gave her Queen Marie artifacts to Maryhill Museum.

*This detail of a 19th-century Russian quadripartite icon depicts Saint Charalampios, a priest in Magnesia in Asia Minor during the third century A.D. who was martyred for his Christian beliefs. He became the patron saint against the plague and cholera.*

The Russian icon collection at Maryhill Museum is another tribute to Queen Marie of Roumania. Many of the icons in the collection were brought by Marie when she dedicated the museum in 1926; others that had one time belonged to Marie came to the museum as gifts from Alma Spreckels.

Although Marie's early religious training was in the Church of England, her mother remained devoutly Russian Orthodox and, in fact, always kept in her personal employ an Orthodox priest and two Russian chanters. Childhood holidays took Marie to Imperial Russia, where incense, lofty chants, and antique icons were part of young Marie's association with her Romanov cousins.

Once Marie married Ferdinand of Roumania, she was obligated to adopt the Roumanian Orthodox faith and to promise to raise her children in the state church. Despite her Protestant upbringing, Marie was drawn to the ceremonious Orthodox

Inset: ***Christ as Pantocrator (Vsederzitel)***, **Russian, 17th century, egg tempera on panel with brass and enamel riza, 10 x 12.25 inches. Gift of Robert Campbell.** Photograph by Jerry Taylor.

Left: **Detail of a Russian quadripartite icon, *Saint Charalampios*, 19th century, egg tempera on panel, 17 x 21 inches. Gift of Queen Marie.** Photograph by Jerry Taylor.

faith. Marie's theatrical and sentimental personality, her own interests in mysticism and symbolism, and her love of the Roumanian people allied her with the Orthodox religion. Her homes in Roumania were decorated with icons and other religious paraphernalia. Even in death, Marie held an icon of the Virgin and Child. When, in accordance with her wishes, her heart was removed from her body and placed in a small gold casket, it was interred in a small Orthodox chapel at Marie's home in Balcic by the Black Sea.

Icons such as those revered by Queen Marie are sanctified images of saints and are an essential part of Eastern Orthodox Christian worship. Typically, icons are paintings made in egg tempera on portable wooden panels, often embellished by a *riza*, a metal covering designed to protect the painting from wear. An example of this in the Maryhill collection is the 17th-century icon *Christ as Pantocrater (Vsederzitel)*. In this icon, Christ is shown as the Pantocrater, the Divine Creator and Redeemer of the world, seen from the waist up, giving the sign of blessing with his right hand and holding the open Gospel with his left. The elaborate metal and enamel riza covers the wooden panel up to the contours of the figure and adds a decorative background with its enameled filigree and cabochon gems.

One of Maryhill's icons known to have belonged to Queen Marie is the *Mandylion*, an early 18th-century Russian icon in the shape of a truncated cross. The central image is the face of Christ, a traditional image referring to a legend of King Abgar of Edessa, who was suffering from an incurable disease. The story says that the king sent a messenger to Christ, imploring Christ to come and heal him. Unable to visit the king, Christ pressed his face into a cloth, creating a miraculous image. This he sent back with the messenger to Abgar, who was restored to health. Again, this unusual icon is protected by a riza, made in the late 19th century. On the vertical member of the cross is the verse from Saint Matthew (22:37): "You shall love the Lord your God with all your heart and with all your soul and with all your mind."

Queen Marie of Roumania's personal art objects and artifacts are among the many collections that make Maryhill Museum unique. In no other museum, in the United States or Europe, is there a collection that documents the dazzling personality and the daring accomplishments of this thoroughly modern queen. In 1990, Marie's grandson, the exiled King Michael of Roumania, visited Maryhill Museum and, in the museum his grandmother dedicated in 1926, experienced the Roumanian heritage that was lost to him in the aftermath of World War II. Though it sits at a great distance—geographically and culturally—from Marie's adopted Roumania, Maryhill Museum preserves a glimpse into her royal life and regal heritage.

# LOIE FULLER
## MODERN DANCER

An American dancer named Loie Fuller was the friend responsible for convincing Sam Hill to turn his concrete shell of a mansion into a museum of art. She was born Mary Louise Fuller in Fullersburg, Illinois, in 1862, the daughter of a tavern keeper. Her interest in performance probably began in her father's concert hall–saloon and with her early experiences as a child temperance lecturer. By the time she was 16, having moved to New York to seek fame and fortune on the stage, she was playing in vaudeville and burlesque and even taking boy roles in Buffalo Bill's final theatrical production. She had also started to change her name: from Mary Louise to Louise to Lois, then finally Loie.

Who knows where Loie's acting career might have taken her were it not for her part in an obscure little play called *Quack, M.D.* during the fall of 1891. Loie's role required that

she lapse into a trance. To play the part, she donned an old Hindu costume given to her by an Indian officer in London and, amid dim lights and soft music, swirled hypnotically across the stage.

> "My robe was so long that I was continually stepping on it and mechanically I held it up with both hands and raised my arms aloft, all the while that I continued to flit around the stage like a winged spirit. There was a sudden exclamation from the house: 'It's a butterfly! A butterfly!' To my great astonishment sustained applause burst forth."

With Loie's accidental discovery of her "Serpentine Dance," she had found her métier. She became obsessed with dance and, specifically, the dramatic special effects she could produce by wafting across a stage lit by colored lights. Determined to dance for European audiences, Loie made her way to Paris, where she made her debut at the Folies-Bergère.

Inset: **Loie Fuller in costume for her "Dance of the Serpents," 1896.**
Photograph by Reutlinger.

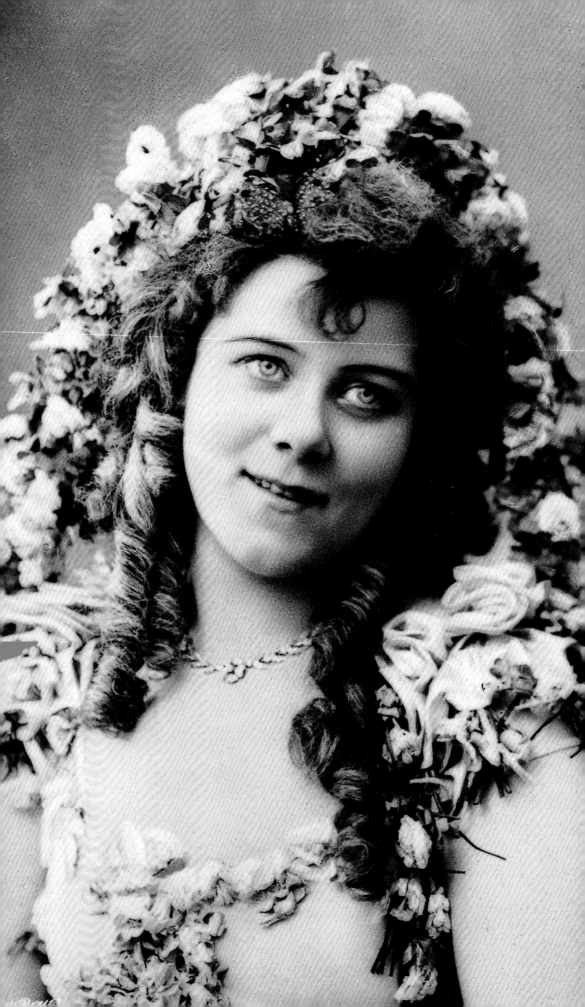

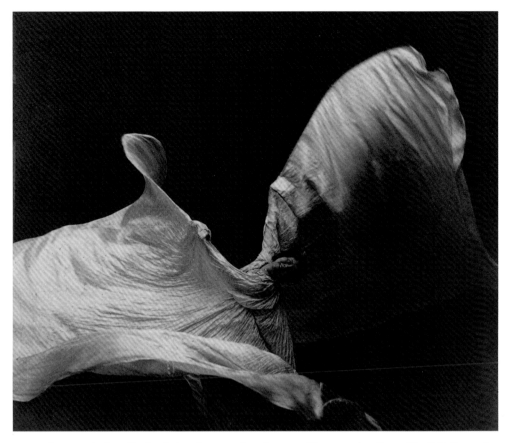

Above: **The "Lily Dance,"
1900.** Photograph by Isaiah
W. Taber; courtesy of the
Musée d'Orsay, R.M.N.

Left: **Loie in costume
for the "Dance of the
Flowers," 1895.**
Photograph by Paul Boyer;
courtesy of La Bibliothèque
Nationale.

In fact, Loie hardly had the figure of a dancer. Short and stocky, she had no classical ballet training. Her dance vocabulary included few jumps and was based on great, sweeping arm gestures and emphatic twists and bends of the torso. These movements Loie combined with long rushes across the stage, whirling turns, and a movement in which she knelt with one leg outstretched, arms flowing, torso arched, and her hair sweeping the floor. Nonetheless, Loie's innovative dancing style took Paris by storm. With her dances called "Serpentine," "Violet," "Butterfly," and "La danse blanche," she became a sensation—the *fée lumineuse*, the Fairy of Light. She brought respectability to the Folies-Bergère, where she instigated matinée performances for ladies and children. In an early review, the critic Rastignac wrote of her:

"One's eyes follow Loie Fuller, who undulates and turns like a dervish, as a child follows from afar the slow flight of the dragonfly, whose iridescent wings have exactly
the changing reflections of the robe of the American . . ."

Roger Marx, a respected art critic and ardent supporter, describing Loie's earliest costumes, said, "the borders are engarlanded with frills and roses . . . the panels are armored with serpents with silver scales . . . strewn with butterflies spreading the mirror of their ocellate wings . . ." But before long, Loie's innovative use of costume and theatrical lighting

transcended mere temporary fashion and became a significant contribution to modern dance. As Loie's dancing style developed, her skirts became more and more voluminous. She amplified her ability to manipulate her skirts by having wands sewn into the insides of the garments. These wands were made of aluminum or bamboo and, attached to the lower part of the skirt, were easily grasped by the dancer. With the hidden wands, Loie was able to toss billows of diaphanous silk into the air, to heights of 10 or 12 feet. Loie's costumes became so expansive that her skirts contained up to 120 yards of translucent, iridescent silk. Sometimes the fabric was painted or dyed to be illuminated by white stage lights; at other times the natural silk was left to shimmer under the glow of changing colored lights.

Theatrical lighting was another component of Loie's unique dancing style. Not long before Loie's emergence, classical ballet dancers were lit by dreary, flat gas lights. Loie, on the other hand, was obsessed by the possibilities offered by electrical lighting and spent her career exploring the mechanics of various lighting devices. She experimented with using a mirrored room as her stage, in order to infinitely multiply the sources of light. For her "Fire Dance" she developed a glass floor, illuminated from below; the rest of the stage would be dark as Loie's costumes absorbed the light under her feet. A variation of this design involved a glass pedestal set atop the glass floor, so that, with deft lighting tricks, the dancer would appear to be suspended in thin air. Additionally, Loie carefully prepared hand-colored slides made from molded glass, which were projected using large lantern projectors. Loie painted abstract designs on the slides, and the irregularities of the patterned surface created richness and depth as light passed through.

Loie's dances were accompanied by serious and contemporary classical music as well as compositions Loie commissioned specifically for her dances. Her famous masterpiece performance, "Fire Dance," was always performed to Richard Wagner's *Ride of the Valkyries.* Edvard Grieg's *Peer Gynt,* Igor Stravinsky's *Fireworks,* and Claude Debussy's *Nocturnes* were among the musical pieces included in Loie's repertoire, as well as two works, *The Thousand and One Nights* and *The Orchestration of Colors,* composed by Armande de Polignac especially for Loie.

By the time Loie's career reached its zenith with her own pavilion at the Paris Exposition Universelle of 1900, the art nouveau movement had also reached its apogee. The art nouveau style embraced a feminine essence, incorporating flora and fauna embellished with sinuous curves and tendrils. The idea of the "femme-fleur" emerged, and artists explored the idea of metamorphosis—the emergence of a butterfly from its cocoon, the transformation of a bud to a flower. To artists of the art nouveau, "La Loie," as she was called, was an enchantress who became "the marvelous dream-creature you

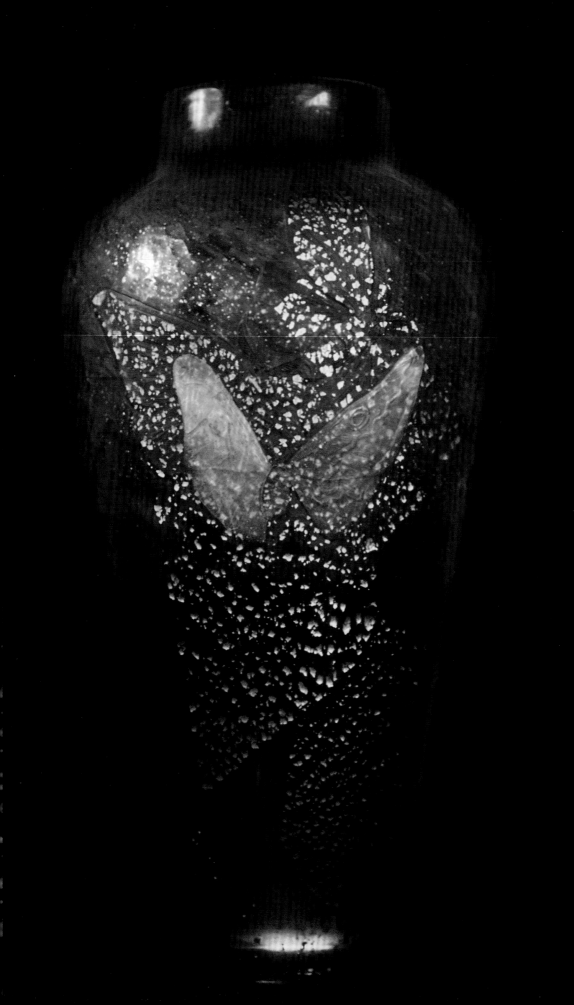

see dancing madly in a vision swirling among her dappled veils which change ten thousand times a minute." Loie's own metamorphoses into flickering visions of a butterfly, a lily, a serpent, a flame became the living embodiment of the art nouveau style.

Loie's intoxicating performances fired the imaginations of other fin de siècle artists, writers, and intellectuals, who were increasingly turning to dance hall life for inspiration. She personified Charles Baudelaire's famous lines:

"I have sometimes seen, in the depths of a banal theater, a being who was only light, gold, and gauze."

As muse to an entire artistic movement, Loie spawned an array of representations by more than 70 artists. Her illusive dance became the subject for poster artists such as Toulouse-

*An assiduous amateur botanist and entomologist, Emile Gallé (1846-1904) was the foremost glass artist of the art nouveau movement. He experimented with colored glass, incorporating shimmering flecks of metal foils and trapping mists of air bubbles within the walls of a vessel to enliven the surface.*

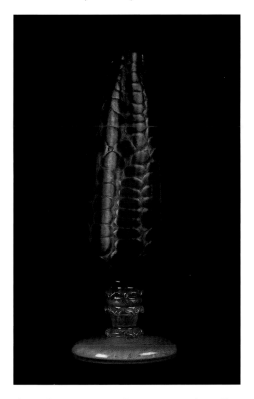

Lautrec, Jules Cheret, Manuel Orazi, Paul Collins, and Will Bradley and sculptors such as Théodore Rivière, Pierre Roche, Francois Raoul Larche, Rupert Carabin, and even Auguste Rodin.

Master glassmakers—Emile Gallé, René Lalique, and Louis Comfort Tiffany—were especially captivated by Loie's art form and were inspired to incorporate her dance into their own art nouveau designs. Gallé in particular, who was known for his pioneering experiments in coloring glass to achieve the most luminous effects, admitted that "he was led to seek new colorings by seeing the beautiful light effects invented by Loie Fuller." After attending one of Loie's performances at the Folies-Bergère, Gallé wrote that her dance made him think of "metempsychoses," the transfiguration of souls. So inspired

Inset: **Emile Gallé (French, 1846-1904), Corn Cob Vase, c. 1900, glass, 2.5 inches diameter x 10.5 inches. Gift of Alma de Bretteville Spreckels.**

Left: **Emile Gallé (French, 1846-1904), Large Vase with Butterflies, c. 1900, glass, 4.5 inches diameter x 15 inches. Gift of Alma de Bretteville Spreckels.** Photographer unknown.

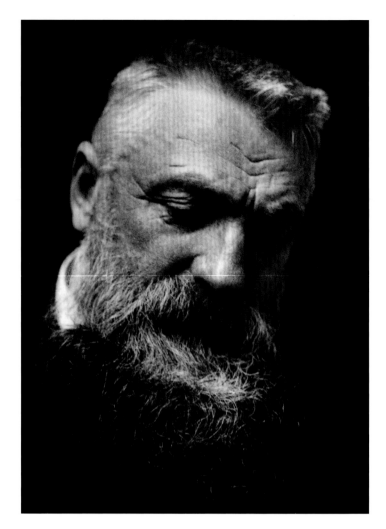

was he by Loie's transformations of light, color, and movement that he acquired a sculpture of her as a reminder of her art form.

Loie met the sculptor Auguste Rodin during the summer of 1898 and they immediately found in each other kindred artistic spirits. Loie's dance imagery of evanescent figures veiled in a swirling mass of translucent fabric evoked Rodin's own search for the integration of movement, form, and atmosphere. Loie cultivated their friendship by hosting Rodin and his partner (later his wife) Rose Beuret at her home and frequenting the sculptor's studio at Meudon; she even appealed to Rodin to create a sculpture of her. (In fact, evidence suggests that the master did create one bronze head of Loie Fuller and one drawing, although the dates and whereabouts of these works are unknown.) Rodin recognized Loie's artistic achievements by saying:

"Mme. Loie Fuller, whom I have admired for a number of years, is, to my mind, a woman of genius, with all the resources of talent. All the cities in which she has appeared, including Paris, are under obligations to her for the purest emotions. She has reawakened the spirit of

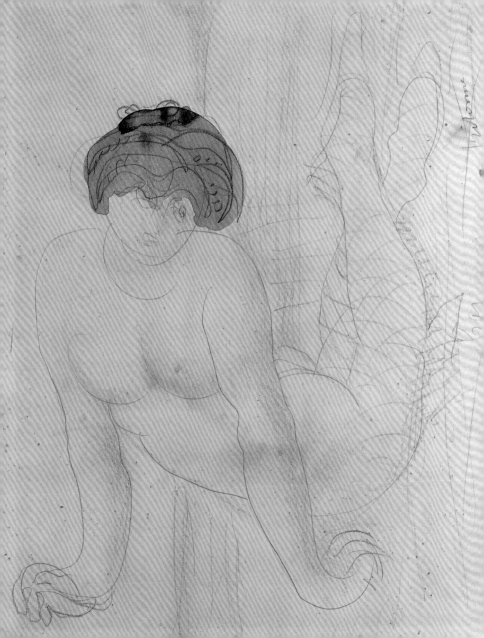

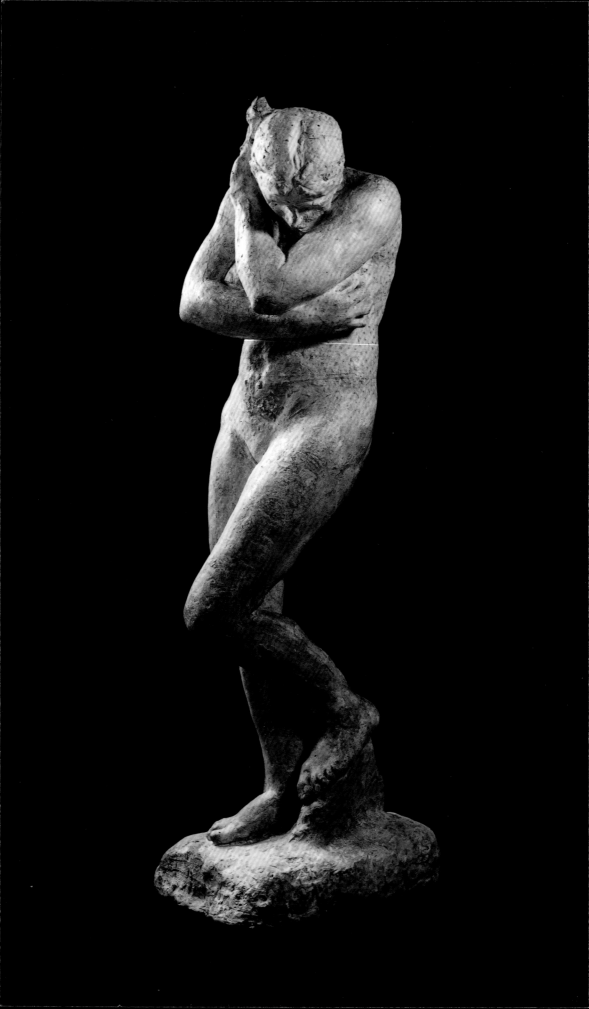

antiquity, showing the Tanagra figurines in action. Her talent will always be imitated, from now on, and her creation will be reattempted over and over again, for she has re-created effects and light and background, all things which will be studied continually, and whose intial value I have understood."

While Loie certainly introduced the artistic possibilities of the dance to Rodin, she also introduced other dancers to him, dancers who inspired Rodin's abilities as a sculptor. Isadora Duncan, who arrived in Paris in 1900 and danced briefly in Loie's troupe, was a favorite subject for Rodin. So, too, was a Japanese actress known by the stage name of Hanako, who joined Loie's company in 1904. Rodin, captivated by Hanako's Kabuki-inspired expressions, produced more studies of her than of any other model.

Loie's relationship with Rodin was by no means her only friendship with a celebrity. Other Parisian friends included the novelists Alexandre Dumas *fils* and Anatole France, and the astronomer Camille Flammarion. She even befriended Pierre and Marie Curie when she sought their advice in creating a radium dance, for which she intended to paint the luminescent element onto her costumes! (Luckily, the Curies explained that radium was far too dangerous for Loie's dance experiments.)

But Loie's most controversial friendship was with Queen Marie of Roumania. Loie met Marie in Bucharest in 1902 during one of the European tours of her dance company. Prince Ferdinand and Princess Marie attended one of Loie's performances in the theater's royal box. So much did the princess love Loie's dramatic performance—which stylistically coincided with Marie's own theatrical tendencies—that she asked Loie to perform a matinée so that Marie's children could see her dance. Loie gratefully agreed to dance at the palace. Upon meeting the future queen, Loie wrote, "I actually forgot where I was, and I fancied myself in the presence of a legendary princess in a fairy-tale chamber." For the rest of their lives, Loie and Marie shared a passionate friendship, exchanging volumes of letters in which Loie encouraged Marie to publish some of her poetry and children's stories. Loie also had a propensity for meddling in Marie's personal life and affairs of state, a trait that frequently strained the relationship.

As Loie approached middle age, her ailing health, her expanding girth, and the vicissitudes of fashion forced her to expand her enterprises. After the Paris Exposition Universelle, Loie had a small troupe of dancers who performed with her, managed by her live-in, lifelong companion, Gabrielle Bloch. By 1908 Loie had organized a school of dance, where she trained girls from ages 8 to 20 in her unique style. She also assumed the role of self-appointed art agent for Auguste Rodin and others of her cadre of French artists, seeking to introduce

*In October 1880 Rodin wrote that* The Gates of Hell *were to be flanked by "two colossal figures, Adam and Eve." The function of the biblical pair was to suggest the origins of the sufferings endured by the figures on the* Gates.

*Rodin used a beautiful, well-known Italian woman as his model for Eve. As he worked, he noticed that her dimensions gradually appeared to change. He wrote:*

"Without knowing why, I saw my model changing. I modified my contours naively following the successive transformations of ever-amplifying forms. One day, I learned that she was pregnant; then I understood. The contours of the belly had hardly changed, but you can see with what sincerity I copied nature in looking at the muscles of the loins and sides.

"It certainly hadn't occurred to me to take a pregnant woman as my model for Eve; an accident—happy for me—gave her to me, and it aided the character of the figure singularly. But soon, becoming more sensitive, my model found the studio too cold; she came less frequently, then not at all. That is why my Eve is unfinished."

Left: **Auguste Rodin (French, 1840-1917),** *Eve,* **1881, plaster, 18 x 20 x 69 inches. Gift of Samuel Hill.** Photographer unknown.

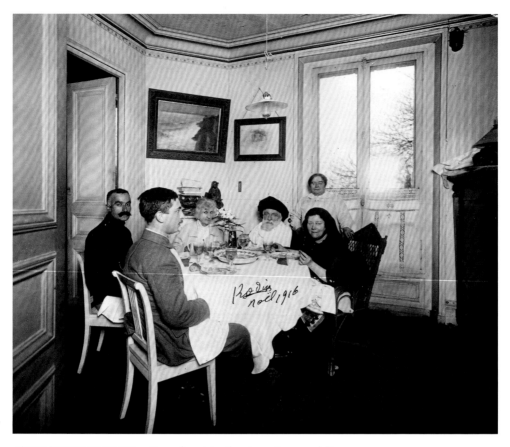

Above: **Auguste Rodin and Loie Fuller (seated, far right) on Christmas Day, 1916, with Rose Beuret, two unidentified soldiers, and server.**
Photograph courtesy of the Cleveland Museum of Art.

French art to the American public.

It was in 1903 that Loie first brought Auguste Rodin's art to American audiences. She was scheduled to begin an American tour in Brooklyn and took the opportunity to assemble an exhibition of a few of Rodin's sculptures, along with a variety of representations of herself, at the New York National Arts Club on West 34th Street. The show lasted only one week, but gave New Yorkers their first American viewing of Rodin's major works, including *Head of Balzac, Adam, Eve, The Thinker,* and *The Hand of God.* But much more significantly, by 1914—on the eve of World War I—Loie had met the San Francisco socialite Alma de Bretteville Spreckels. Their meeting had been arranged at a dinner party in Paris given by an art dealer who was feting Alma on her first trip to Paris. The two women became fast friends, and Loie hastened to introduce Alma to the famous Auguste Rodin.

At that time planning had begun for the Panama-Pacific International Exposition in San Francisco, to celebrate the opening of the Panama Canal. The French pavilion, which was to be built as a replica of the Palais de la Légion d'Honneur in Paris, would exhibit examples of French art, and Alma wanted to supplement the exhibit with objects from her own collection. With Loie's encouragement, Alma purchased six Rodin sculptures, including *The Thinker,* for the exposition. (Later, Alma and her husband Adolf rebuilt a permanent replica of

the Palace of the Legion of Honor as a gift to the city of San Francisco.) Loie and her dance troupe performed at the exposition, but also in benefit performances arranged by Alma to support her charitable projects in war-torn France and Belgium. Loie even specially choreographed an "Opal Dance," a performance in honor of a black gem that Alma planned to raffle off for charity.

At the Panama-Pacific Exhibition in 1915, Alma introduced Loie to her friend Samuel Hill, whom Alma had met through a mutual friend in Portland. With World War I under way, Loie's career was temporarily stalled (but not completely derailed: she crossed the Atlantic 12 times during the war). Like Alma, Loie had found another lifelong friend in Sam Hill, a man with whom she shared many common interests and ambitions. Both were close friends of Queen Marie of Roumania and both were proponents of the Roumanian cause during and after the war. At one point Sam even suggested to Loie that the two of them meet Queen Marie in Petrograd for Christmas in 1916, and authorized Loie to withdraw travel funds from his personal account in Paris.

Instead of traveling to Russia, Loie traveled to Maryhill in the summer of 1917 to visit Sam and view for herself Sam's town and concrete chateau. The little dancer was certainly dismayed at the vision she saw there—a site as desolate as it was grand, and a natural landscape as opposite as one could imagine from the City of Lights. Nonetheless, Loie immediately concluded that Sam's unfinished mansion should house a museum of art. Following Loie's persuasive arguments, Sam handed her a typewritten statement on July 24, 1917, which read:

> "After the eloquent pleading of today, I have decided to dedicate my new chateau at Maryhill, Washington, to a museum for the public good, and for the betterment of French art in the far Northwest of America. Your hopes and ideals should be fulfilled, my dear little artist woman."

At the same time, Sam announced a message for the artists of France, telling them: "In the autumn of 1918 you can arrange with our friend Loie Fuller to hold the first salon, when we will open the museum with our first exhibition." With this decree, Sam Hill and Loie Fuller launched the Maryhill Museum, although it would not open for another 23 years.

Not surprisingly, Loie's lifelong fascination with light and special effects led to an interest in cinematography. Loie had been recorded on film on a three-minute, hand-colored reel by Pathé in 1906, but in 1919, at the age of 58 and at a time when women filmmakers were exceedingly rare, Loie embarked on her own film project. She decided to adapt to film a fairy tale written by Queen Marie, *Le Lys de la Vie* (*The Lily of Life*). Loie had already presented the story as a ballet earlier that year (and it would be performed again during Queen Marie's visit to the United States). The story involves a

*One of Loie's favorite sculptors was her close friend Théodore Rivière, who made many small sculptures of the dancer that she obtained for herself and friends. Even after Rivière's death in 1912, Loie purchased works from the artist's widow. The small bronze below depicts Loie in her "Lily Dance." So enveloped is the dancer by her voluminous gown that only her head and tiny feet emerge from the drapery.*

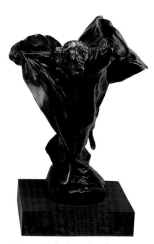

Above: **Théodore Louis-Auguste Rivière (French, 1857-1912),** *Loie Fuller,* **c. 1898, bronze, 6 x 6 x 10.5 inches. Gift of Alma de Bretteville Spreckels.**

*The Rodin collection at Maryhill Museum is due to Loie Fuller's friendships with both the sculptor and Samuel Hill. In one of Loie's campaigns to introduce the art of Auguste Rodin to the American public and raise funds for European war relief, she had convinced Rodin to lend a number of drawings for an album, which was to be sold for the benefit of wounded French soldiers. Endlessly plagued by financial difficulties, Loie borrowed money, secured by the artwork, in an effort to publish the album. Sam Hill paid off Loie's bank loan in 1921 and acquired the drawings for the Maryhill Museum. It is believed that Sam bought all but five of the Rodin works now at Maryhill Museum.*

young prince betrothed to a princess; unbeknownst to the young lovers, the princess' younger sister is also in love with the prince. When the prince is stricken with a mortal illness, the older sister stays by his side, while the younger princess sets out on a terrifying journey to find the "lily of life," the only antidote to her beloved's illness. Her search takes her through a haunted forest, full of witches and goblins, where she is pursued by giant hands that pluck at her from the trees. Upon her successful return, the prince regains his health, only to remain true to the elder princess. Her heart broken, the young princess dies of unrequited love.

The cast of *Le Lys de la Vie* was small. A well-known French actress and singer, Damia, played the part of the witch, while the role of the prince was a debut performance by a young French actor, René Chomette. (Later, Chomette became René Clair, one of France's leading motion-picture producers. His 1942 film *Ma Femme est une Sorcière* [*I Married a Witch*] inspired Jean Cocteau's 1945 stage set for the *Théâtre de la Mode*, now part of the Maryhill collection.) Always an independent innovator, Loie improvised and experimented, often taking the camera into her own hands to achieve her desired effects. Loie had hoped that *Le Lys de la Vie* would succeed commercially, earning a lot of money for Queen Marie's cherished war relief programs, but Loie's notoriously poor financial management made the film a financial failure. Undaunted, Loie went on to make one more film, adapted this time from poetry by Queen Marie, as well as to undertake a film adaptation of *Coppelius and the Sandman*, based on the story by E.T.A. Hoffman.

Loie Fuller made one more trip to Maryhill, this time as part of the entourage surrounding Queen Marie of Roumania, whose dedication of the museum in 1926 united Sam Hill, Loie Fuller, and Alma Spreckels. Loie had contributed to the museum by making Auguste Rodin sculptures available to Sam Hill, but she had also given gifts of her own to the museum's collection. As one of the museum's first trustees, appointed by Sam Hill, Loie donated a collection of models of famous people's hands, cast by Rodin's molder. Her inscription for the gift read, "Dear Mr. Hill: May these hands dedicated to your great work express what they have done for others as a symbol of your own." The collection included the hands of Sam Hill, Queen Marie, Loie Fuller, Victor Hugo, Voltaire, Generals Pershing and Joffre, Sarah Bernhardt, Rudolph Valentino, and various other acquaintances of Loie's.

In 1928 Loie was still working, often directing performances and her film projects from her bed, wearing dark glasses because her eyes had been damaged by 35 years of experimentation with light. When she died later that year at the age of 66, the French press mourned her loss, saying "a magician is dead" and "a butterfly has folded its wings."

Right: **Auguste Rodin (French, 1840-1917), *The Thinker*, 1880, plaster with pencil inscription below the left foot: "A Loïe—Rodin," 7.5 x 7.5 x 15 inches. Gift of Loie Fuller.**

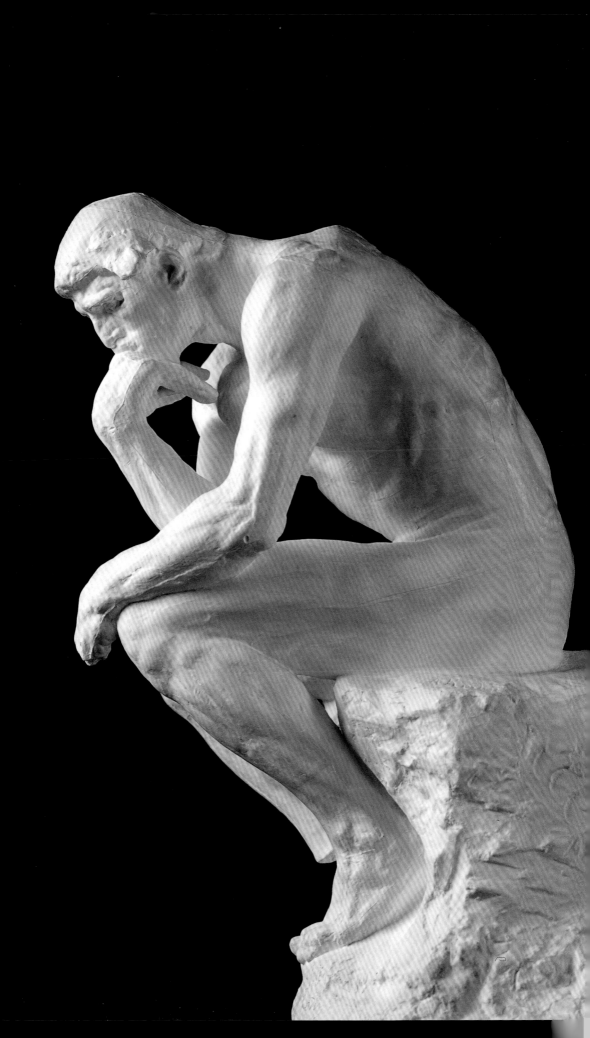

# ALMA DE BRETTEVILLE SPRECKELS
## SAN FRANCISCO SUGAR HEIRESS

Alma de Bretteville Spreckels, the wife of San Francisco sugar magnate Adolf Spreckels, was the fourth founder of the Maryhill Museum. She was a friend of Sam Hill, Loie Fuller, and Queen Marie; after their deaths Alma threw herself into realizing the four friends' shared dream of turning Sam Hill's mansion into a museum of art. Her work on the museum's behalf spanned more than 30 years.

Alma was born Alma Emma Charlotte Corday de Normand de Bretteville on a farm near San Francisco in 1881. Her penniless parents, natives of Denmark, traced their family's roots to French nobility; thus, Alma was named after an ancestor, Charlotte Corday, the royalist who was guillotined during the French Revolution for assassinating Jean Paul Marat in his bathtub. Alma grew up to be a strikingly beautiful young woman, standing six feet tall (hence her nickname, "Big Alma"). Her entrée into the world of art was as an artist's model; her stately figure was chosen as the ideal likeness for Robert Aiken's 1902 sculpture perched atop Dewey Monument in San Francisco's Union Square. In 1908 Alma married the millionaire Adolf Spreckels, a man more than twice her age, and began her life as a San Francisco socialite, art connoisseur, and patron.

Alma had met Loie Fuller in 1914, on her first buying trip to Paris, where she planned to acquire French objets d'art for her lavish mansion at 2080 Washington Street in San Francisco. Although Alma's and Loie's accounts of their first meeting differ as to where their dinner party was held—Alma remembered it as Ciro's, Loie as Paillard's—each noted that she found in the other a kindred soul. Loie immediately began to educate Alma about contemporary French art and introduced her to Auguste Rodin. Soon Alma became a major patron of the master sculptor. By the time Alma and Adolf Spreckels opened the California Palace of the Legion of Honor in 1924, Alma had given the San Francisco museum 31 Rodin sculptures and drawings. (The Legion of Honor now holds 106 works by Rodin, the largest collection outside of France; of these, 96 were gifts from Alma and her family.)

Loie also introduced Alma to Queen Marie of Roumania. Because of her French and Belgian roots and inspired by Loie's example, Alma became engrossed in raising money to send to Europe for war relief during World War I. Loie introduced Alma to Queen Marie, hoping that Alma's generosity would extend to the Balkan nation. Loie won Alma over by recounting the horrors that had befallen Roumania under German occupation. With no medical supplies available, Loie told her, doctors were forced to use sawdust to dress wounds. Alma's heart was touched and she raised funds for medical equipment to be sent to that "great little country." It was through these efforts that Queen Marie and Alma Spreckels became friends well before they met in person; before long, Alma began planning a "Roumanian Room" of artifacts from the queen for the California Palace of the Legion of Honor. Sam Hill was already

Above: **Detail of Queen Marie's furniture. Alma Spreckels donated a number of objects belonging to Queen Marie to Maryhill Museum.**

a close friend of Alma and Adolf Spreckels; indeed, he was godfather to one of their sons. In 1915, when the Panama-Pacific Exposition was being held in San Francisco, Alma in turn introduced Sam Hill to Loie Fuller.

This famous foursome was united in spirit, but not in person until the autumn of 1926, when Queen Marie agreed to venture to Maryhill, Washington, to dedicate Sam Hill's mansion as a museum of art. Alma immediately became involved in the festivities surrounding Marie's arrival in America. Sam Hill enthusiastically asked Alma to be his official hostess for the queen's visit to the West Coast and for her reception in Seattle. Alma arranged to rent her own private railroad cars to meet the queen's *Royal Rumanian* in Saint Paul, Minnesota, and accompany her to the West Coast. In fact, Alma organized a party of 65 friends, relatives, and staff to join the party on the train. However, when Marie's train reached Saint Paul, Alma was outraged to learn that her railroad cars could not be coupled onto the royal train; she would have to join the queen in Spokane, Washington. Alma met Marie, Loie, and Sam in Spokane for the next leg of the journey to Maryhill Museum. But, snubbed by the queen's attendants and by Portland society women who assumed responsibility for the ceremony at the museum, both Alma and Loie remained in Alma's train cars while Queen Marie dedicated the museum "to peace and beauty." Deeply dejected, Alma returned to San Francisco without accompanying Sam and Queen Marie to Seattle.

Despite the international press engendered by the dedication of the Maryhill Museum, the structure and its contents—still packed in crates—remained fallow for many years after the dedication. Within just over a year, Loie had died in Paris, and Marie, no longer queen after her husband's death, had retired in Roumania, never to return to America. Sam Hill died in 1931, but litigation over his estate kept the museum trustees from making any progress toward opening the museum to the public.

By 1937 the litigation over Hill's will was over and Alma was elected to the newly formed board of trustees. Her first gift to the museum included objects that were originally meant for the "Roumanian Room" of the California Palace of the Legion of Honor, but had been turned down by that board. Alma wrote to the secretary of the Maryhill Museum board:

"I am deeply interested in your Museum, and wishing to do something to aid its success, I have decided to loan my fine collection of gold furniture and other objects from the palace of the Queen of Roumania, if you would like to have it.

"The collection includes the queen's gold throne and other unique pieces of Byzantine furniture; the queen's cloth of gold robe which she wore at the time of the coronations of the Tsar and of the King of England; her gold crown, gold goblets, presents which were among the souvenirs of the Royal family, gifts from the Queen of Serbia, etc., etc."

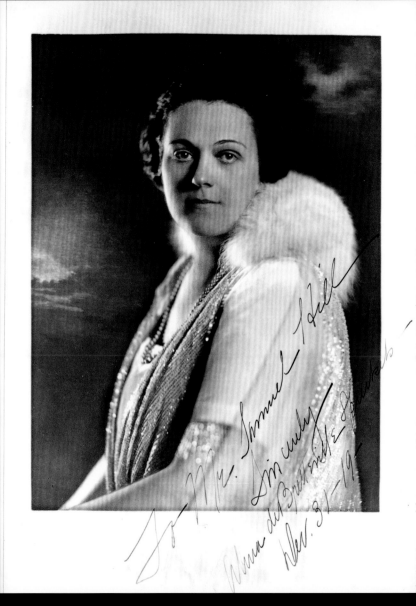

To Mr. Samuel Hill
Sincerely
Anna duPont E. Roberts
Dec. 31 - 19—

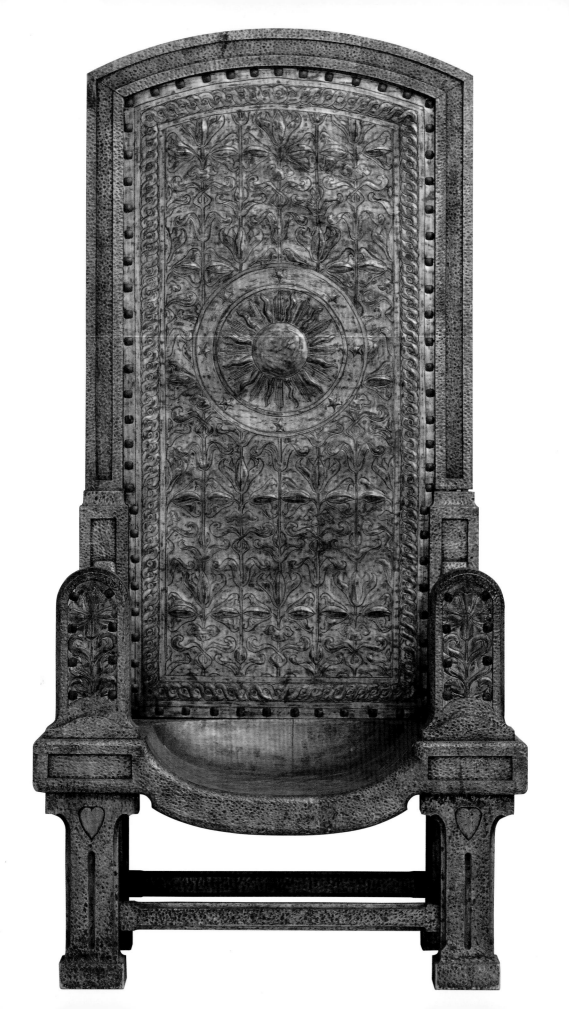

In time, Alma gave much more of her collection to Maryhill Museum, including Russian icons from Queen Marie, her collection of Emile Gallé glass, and several French paintings.

Even though Alma lived hundreds of miles from Maryhill, she became intimately involved in both the governance and administration of the new museum. The first director, Clifford Dolph, a relative of one of the trustees, had originally been hired to unpack crates and build exhibition furniture; the title was bestowed on Dolph for 33 years. Alma addressed volumes of letters to Dolph throughout their 25 years of correspondence, advising the new director on how to manage the nascent museum. Her advice ranged from the helpful to the officious, instructing Dolph to remove carpets from the galleries and urging him to construct a tea room, as "it's imperative that people should be able to buy a sandwich and a cup of coffee without going thirty miles to get it." On the cultivation of future

*Alma Spreckels gave Queen Marie's silver throne of carved wood and leather to Maryhill Museum. The inscription on the seat reads "Presented to Mr. and Mrs. A.B. Spreckels (Mrs. Alma de Bretteville Spreckels) en reconnaissance for what they have done for others—Marie, Queen of Roumania." So proud was Alma of the throne that she commissioned a portrait of herself seated on it by the painter Richard Hill in 1924. During the early years of the museum's history, and at Alma's insistence, Maryhill Museum had postcards made of the portrait, which Alma constantly ordered the museum's first director to send to friends and acquaintances.*

trustees she said, "It is not necessary for a trustee to be an authority on art. Much more important that he be capable of handling the financial affairs of the museum and properties." Alma also advocated for a women's volunteer group:

"I recommend that a Women's Auxiliary be formed. Women are workers, especially club women. It is not always the rich women who are the most generous. The middle class people give their energy, souls, brains and heart and are willing to learn. I am not even a high school graduate. What I know (I am humble about it and have much to learn) has been acquired by reading and traveling. I have visited museums all over the world. I think Maryhill has a great future. My idea is to let the public feel that they are a part of it."

Alma's heroic efforts to preserve Sam Hill's dream were

Left: **Queen Marie's audience chair, wood, leather, and silver, 35.75 x 24 x 70 inches. Gift of Alma de Bretteville Spreckels.**

Inset: **Maxime Emile Louis Maufra (French, 1861-1918), *Bad Weather at Donand*, undated, oil on canvas, 22 x 18 inches. Gift of Alma de Bretteville Spreckels.**
Photograph by Jerry Taylor.

rewarded on May 13, 1940, Sam Hill's birthday, when the doors to the museum were opened to the public. Alma was there to preside over the occasion, unveiling a bronze plaque in honor of Sam Hill. In the first 90 days, more than 30,000 visitors toured the museum.

Although Alma's role as benefactor to Maryhill Museum spanned over more than three decades, perhaps the most important legacy she left to the museum was her help in acquiring the *Théâtre de la Mode*. After the little French fashion mannequins—created in 1945-46 in one-third life size, complete with stage-set tableaux and specially composed music—toured Europe, they were exhibited throughout the United States. The final stop on the American tour was San Francisco. At the end of the exhibition, the San Francisco

organizers tried to send the mannequins back to Paris, but the Chambre Syndicale, originators of the *Théâtre de la Mode,* were unwilling to pay the customs charges to have the dolls returned. While the real gems used in the jewelry made by Van Cleef & Arpels and by Cartier were returned to France, the little wire bodies wearing couture fashions were left in storage in the basement of the City of Paris department store on Union Square (now the site of Neiman Marcus). Later, Alma's friend, Paul Verdier, owner of the City of Paris, used the mannequins in a display celebrating the 100th anniversary of his store.

Inset: *The Palais-Royal stage set by André Dignimont (French, 1891-1965) from the Théâtre de la Mode*, 1945 (re-created by Anne Surgers in 1990), 161 x 80 inches. Photograph by Laurent Sully-Jaulmes.

Right: **Detail of *La Place Vendôme* by Louis Touchagues (French, 1893-1974) from the *Théâtre de la Mode*, 1945 (re-created by Anne Surgers in 1990), 198 x 80 inches.** Photograph by Laurent Sully-Jaulmes.

It didn't take Alma long to suggest that the *Théâtre de la Mode* would find an excellent home in the Maryhill Museum. Verdier agreed, and legend has it that the dolls arrived one day at the Maryhill Museum in unmarked crates—but just in time for the museum to display them when it opened for its 1952 season.

Alma died of pneumonia in 1968 at the age of 86. Fittingly, her funeral was held at the California Palace of the Legion of Honor, with the funeral procession starting in the courtyard where Rodin's *The Thinker* presided. Among Alma's long list of charitable deeds and philanthropic interests extending to both sides of the Atlantic, there is little question that her contributions to the Maryhill Museum allowed the museum to develop during its most vulnerable early years.

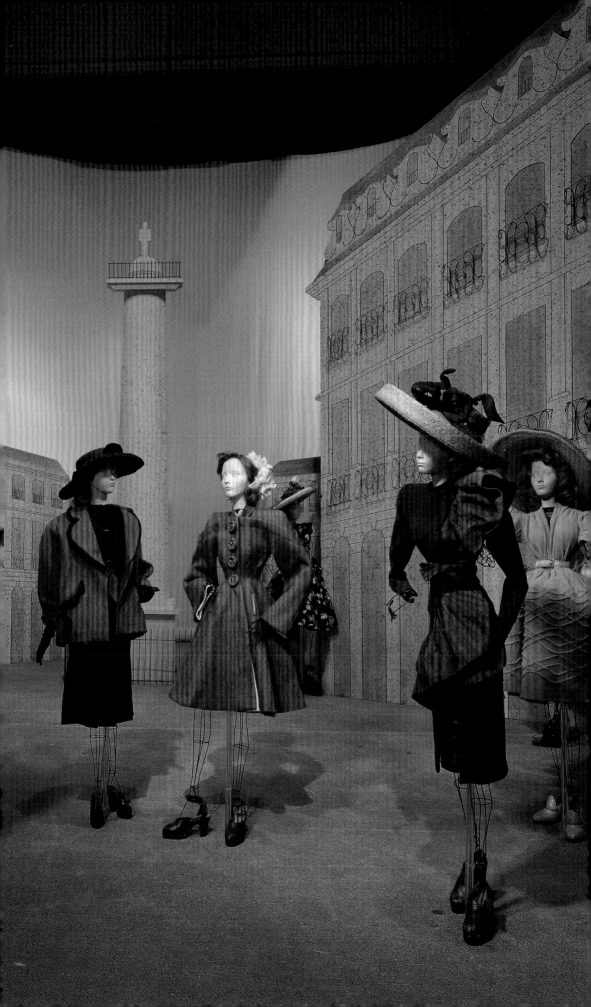

# MARYHILL MUSEUM
## FEATURED COLLECTIONS

## The Auguste Rodin Collection

The Auguste Rodin collection at Maryhill Museum is a world-class collection of sculpture and drawings made by the master recognized as the father of modern sculpture, who lived from 1840 to 1917. Unlike many Rodin collections amassed during the 20th century, the Maryhill works are not posthumous castings; rather, they compose a collection largely assembled by Rodin's friend and contemporary, Loie Fuller, who convinced both Sam Hill and Alma de Bretteville Spreckels to develop collections of his work. The 87 works at Maryhill provide an excellent introduction to the art and life of this French artist as they survey Rodin's life work, from his early years through his maturity, in studies from his most significant monuments, more intimate fragments, and his late drawings.

Rodin's *The Age of Bronze* (1875-76) was the artist's first masterwork, a seminal piece from early in his career, made when Rodin was 35 years old. The artist used a Belgian soldier as the model to create a full-scale sculpture of a nude male, originally holding a staff in the left hand and exhibited as *The Vanquished.* When it was exhibited again in 1880 at the Paris Salon, Rodin changed the title to *The Age of Bronze*, believing that the work represented "one of the first inhabitants of our world, physically perfect, but in the infancy of comprehension, and beginning to awake to the world's meaning." The work was admired—but also criticized, and publicly denounced as *sur-moulage* (casting from life) because of the veracity of the work.

Above: Auguste Rodin (French, 1840-1917), fragment of a left foot, c. 1893, bronze, 4.5 x 2 inches. Gift of Samuel Hill. Photograph by Jerry Taylor.

With *The Age of Bronze,* Rodin began his departure from the accepted style of French taste in sculpture. Instead of producing fine-lined, allegorical figures in rococo-inspired poses, Rodin turned his attention to investigating the human form as a vehicle to express human emotion. Removing all the artifice and accouterments that were standard in academic figures, Rodin became obsessed with the evocation of movement and the play of light and shadow on the human figure. As the noted Rodin scholar Albert E. Elsen said, "Rodin challenged convention and transformed tradition."

Rodin's magnum opus was *The Gates of Hell*, a commission he received in 1880 to design a decorative door for a proposed museum of decorative arts. Rodin developed a design based on Dante's *Divine Comedy,* in which bas-relief figures writhe and fall within the architectural framework. The composition of *The Gates of Hell* included the monumental figures of *Adam* and *Eve* freestanding before the *Gates*, forming the base of a pyramid. Rodin's famous *The Thinker,* originally meant to suggest Dante contemplating his fate in hell, occupies the center of the tympanum over the doors.

Over the next 20 years Rodin modified, added, and extracted figures until the *Gates* evolved, conceptually and sculpturally, to

The title for *Je Suis Belle* derives from the first line of the poem "Beauty" by Charles Baudelaire. During the time this sculpture was executed, Rodin was also illustrating an edition of Baudelaire's Les Fleurs du Mal, which included the poem "Beauty," which is also inscribed on the base of the sculpture.

I am beautiful as a dream of stone, but not maternal; And my breast, where men are slain, none for his learning, Is made to inspire in the Poet passions that, burning, Are mute and carnal as matter and as eternal.

*Charles Baudelaire*

include 186 figures depicting the depth and bleakness of the human condition. Throughout his lifetime, Rodin mined the concepts explored in the *Gates* to develop innumerable independent works of art. Nine sculptures in the Maryhill collection were originally conceived to be part of *The Gates of Hell*: *The Thinker, Eve, Je Suis Belle, The Fallen Caryatid, Danaïd, Despair, Polyphemus, The Man with the Broken Nose,* and the small *Plaque from the Gates of Hell*.

Rodin's first completed major public monument was *The Burghers of Calais*, commissioned in 1884. It commemorated a historical event narrated in the medieval *Chronicles* of Jean Froissart. In 1347, during the Hundred Years' War between France and England, the city of Calais on the northern coast of France endured an 11-month siege by the British. In an effort to save the city from annihilation, six leading citizens—burghers—of Calais volunteered as hostages in exchange for the lifting of the siege. King Edward III demanded that the six, wearing sackcloth and halters and carrying the key to the city, present themselves at his camp for execution. At the intercession of King Edward's wife, the pregnant Queen Philippa, the lives of the burghers were spared at the last moment.

Rodin's complete monument portrays the six men as they are about to leave their city. Rodin made numerous studies, isolated figures, busts, and portraits of the burghers as he developed the monument. At Maryhill, the *Mask of Jean d'Aire* and a small model of *Jean de Fiennes* are examples of Rodin's studies for *The Burghers of Calais*.

Rodin was later commissioned to create a monument to the French literary genius Honoré de Balzac. In 1891, the Société des Gens de Lettres de France, led by Emile Zola, offered Rodin the opportunity to immortalize the great writer. In developing his ideas for the monument, Rodin immersed himself in the study of Balzac. He researched his life, read his books, and reflected on photographs and other images of the author, attempting to capture the physical appearance as well as the spirit of Balzac. The writer was a man of passions; he was known as an insatiable lover, careless debtor, social climber, and art collector. He was nonetheless a compulsive writer who would exhaust himself by writing 16 hours a day.

The sculptor turned to the poet Lamartine, who described Balzac's head as "the embodiment of an elemental force." Rodin emphasized the writer's head as the spiritual and physical apex of the monument. The artist produced over 50 studies for the monument, most of them heads such as the example in the Maryhill collection. The deeply gouged eyes, heavy brows, the sensuous sneer of the mouth, and the shock of unkempt hair reveal the character of Balzac and allude to his prophetic insights.

Right: **Auguste Rodin (French, 1840-1917),** *Je Suis Belle (I Am Beautiful)*, **c. 1881-82, plaster, 11 x 12.75 x 27.75 inches. Gift of Samuel Hill.**

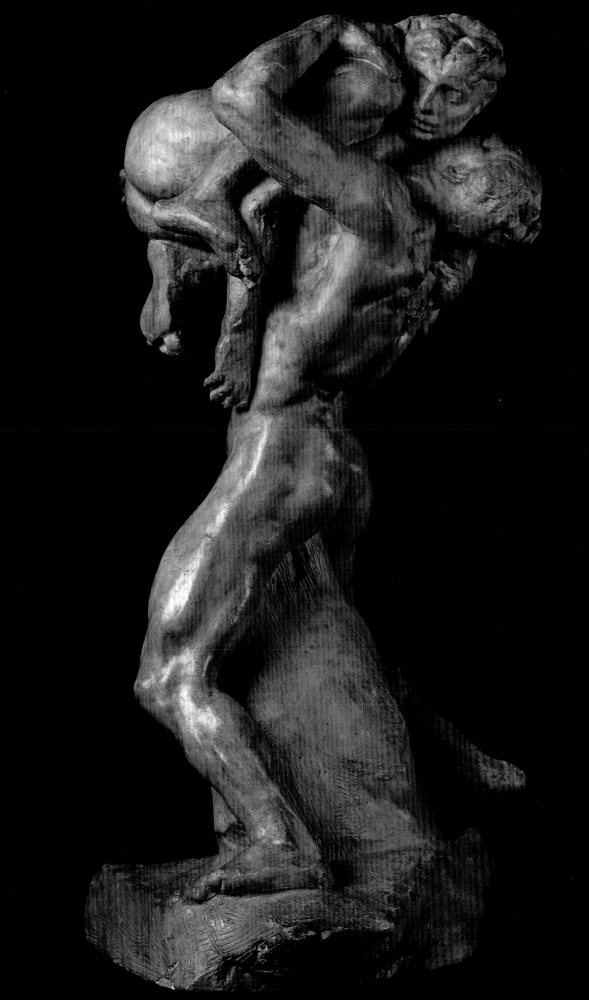

When Rodin exhibited the finished *Monument to Balzac* in 1898, a public scandal ensued. Ridiculed for its unconventional depiction of the writer, the monument was rejected by the Société. Rodin kept the work and placed it in an open meadow at his home in Meudon.

One of Rodin's most important legacies to modern art is that he boldly embraced the fragment as a complete and independent work of art. Rodin's contemporaries were accustomed to working with fragments. Indeed, 19th-century artists carefully studied and sketched Greek and Roman antiquities, early Christian reliquaries, primitive art from Africa and pre-Columbian America, and European architectural fragments in which partial figures were commonplace. However, according to academic tradition, such fragmentary objects were considered incomplete and imperfect, certainly not works of art.

Rodin's first exhibited fragmentary figure was *The Man with the Broken Nose*. He went on to experiment with fragments, making hundreds of casts of heads, torsos, arms, legs, hands, and feet, which he saved to combine and recombine to create new figures. The fragments were numbered, catalogued, and saved to be used perhaps years later. Even in a foot or a hand, one notices the bravura and expressiveness in the smallest anatomical detail. The Maryhill collection contains a number of fragmentary figures, which are valuable both for their beauty and for the insights they provide into the way Rodin worked.

Rodin became interested in the dance—and its possibilities for artistic subject matter—through Loie Fuller, who, he said, "opened the way to the art of the future." He was intoxicated by the performances he saw when they had neighboring exhibition spaces at the Paris Exposition Universelle in 1900. That same year, Isadora Duncan—soon to become one of Rodin's subjects—came to Paris. Rodin would visit Isadora at her dancing studio near his own home and studio, and sketch the dancers in rapid, calligraphic line drawings, trying to capture their elegance on paper. Later, Rodin would become entranced by the Russian dancer Nijinsky and would sculpt his athletic dance movements.

Around 1900, Rodin's drawing style evolved dramatically. While he had been in the practice of drawing since childhood, and accompanied his sculptures with trails of studies, project ideas, and even architectural drawings, later in his life Rodin's drawings took on a more spontaneous, lyrical quality. A sculptor conceives the world in the round, in three dimensions—yet it is striking how fully Rodin's line drawings express the body in simple contour and with the sparest details, enhanced by watercolor washes. The Maryhill collection includes fine examples embodying this exquisite style.

*As if for amusement, Rodin hired models or dancers to come to his studio to simply move about as they chose— kneeling, bending, crouching, sitting pensively, combing their hair. He would then execute a line drawing as quickly as possible, without taking his eye from the model. From these studies he developed a nearly inexhaustible store of nude drawings. Later, often years later, Rodin would select line drawings to heighten with watercolor. "Cela donne de la douceur" ("This gives a softness"), Rodin would say, adding the palest color to lend the drawings the fullness of flesh and the soft glow of breath.*

Left: **Auguste Rodin (French, 1840-1917), *Kneeling Woman in a Dress*, c. 1900, graphite and watercolor wash on paper, 9.75 x 12.75 inches. Gift of Samuel Hill.** Photographer unknown.

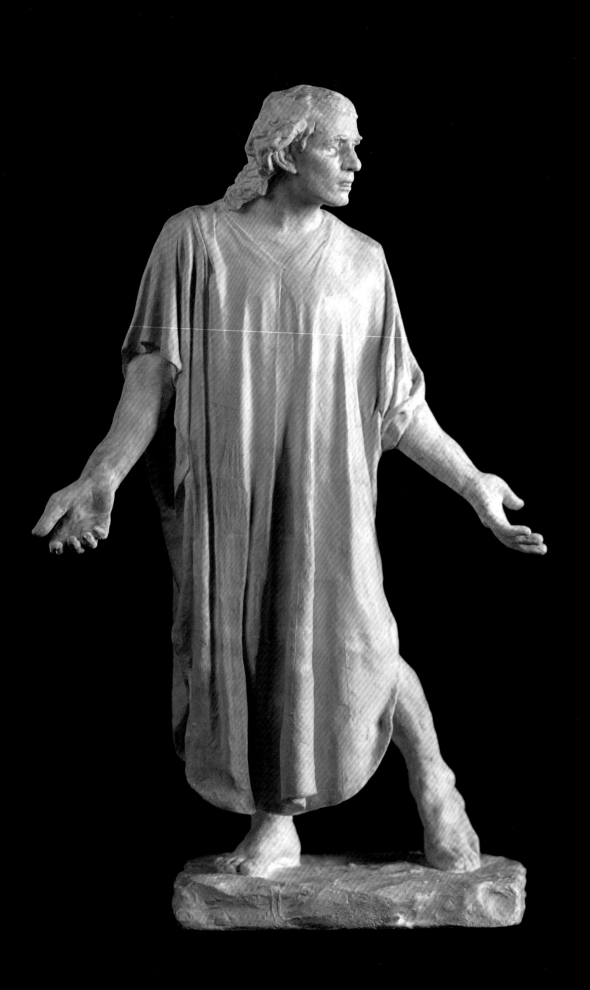

Above: **Auguste Rodin (French, 1840-1917)**, *Kneeling Woman to Left*,
c. 1900, graphite and watercolor wash on paper, 9.75 x 12.75 inches.
**Gift of Samuel Hill.** Photographer unknown.

Left: **Auguste Rodin (French, 1840-1917)**, *Jean de Fiennes* (Study for
the Burghers of Calais), c. 1884-86, plaster, 7.5 x 5.5 x 18 inches.
**Gift of Samuel Hill.**

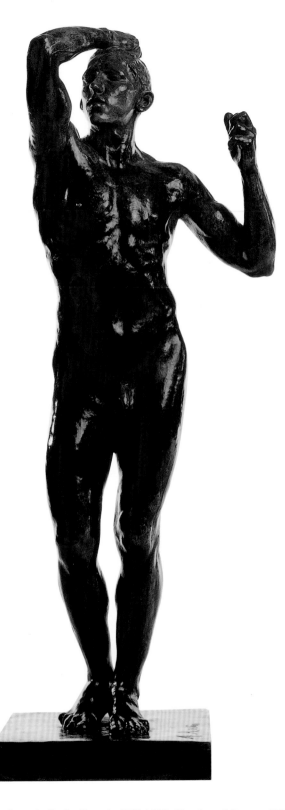

Above: **Auguste Rodin (French, 1840-1917),** *The Age of Bronze,* 1875-76,
**bronze, 9 x 7 x 25 inches. Gift of Samuel Hill.**

Right: **Auguste Rodin (French, 1840-1917),** *The Hand of God,* c. 1898,
**plaster with pencil inscription: "A Loïe—Rodin," 8.75 x 9 x 14.5 inches.
Gift of Loie Fuller.**

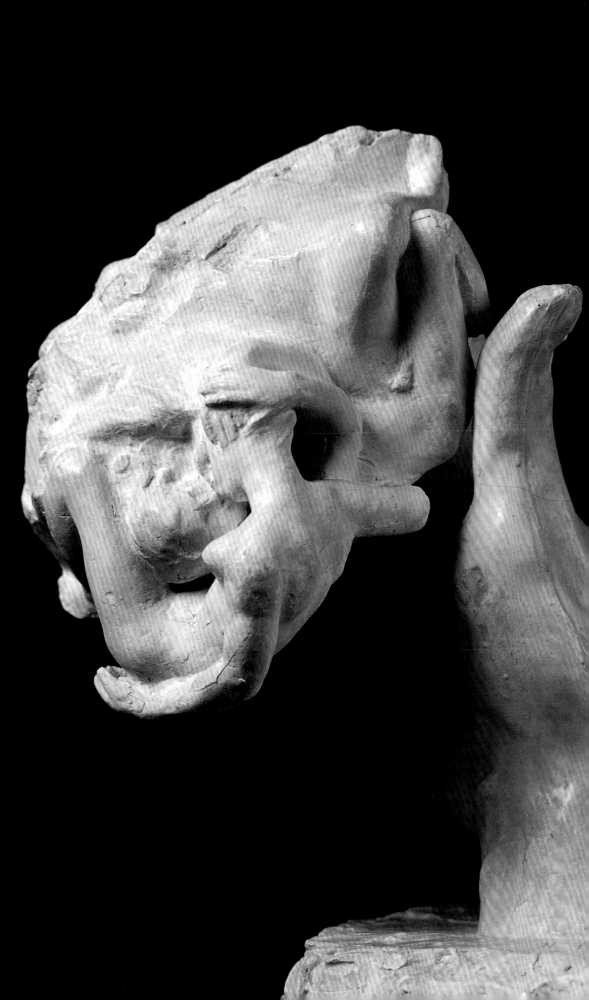

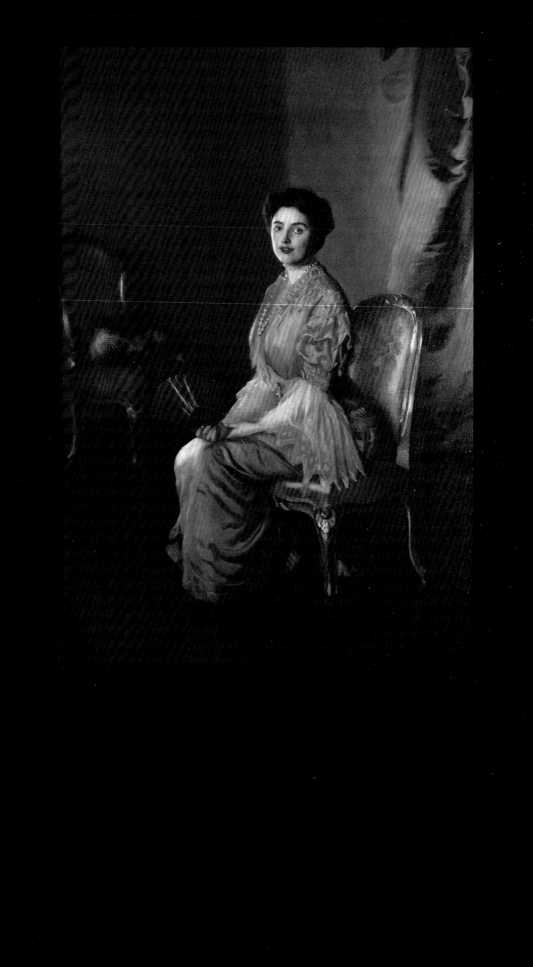

## European and American Paintings

Alma de Bretteville Spreckels gave a number of French paintings to Maryhill Museum, among them works by Eugène Carrière, Ker-Xavier Roussel, Paul Albert Besnard, Charles Guerin, and Maxime Maufra. The remaining works in the painting collection, including significant holdings by Dutch, Belgian, British, and American artists, were acquired by museum purchase during the museum's early years.

Without question, the most important canvas in the Maryhill collection is *Solitude* (page 10), painted by the British artist Frederic, Lord Leighton (1830-1896). As a major proponent of British academic painting, Leighton, along with other Victorian-era artists, was intrigued by the single female figure, captured in a moment of meditation. In the Maryhill painting, the figure is deeply contemplative; she is wearing classical drapery and her enigmatic gaze is cast into the dark pool of water below. With most of the painting in a restrained palette of creamy white and flesh tones against a darker ground, the saffron drapery on which the solitary figure sits is the only punctuation of saturated color.

The realism found in Frederic Leighton's *Solitude* is also explored in a number of paintings by American artists in the Maryhill collection. William McGregor Paxton (1869-1941) is often linked with the American Impressionists, but his studies with Jean Léon Gérôme at the Académie in Paris provided Paxton with a preference and facility for academic art. Maryhill Museum owns three canvases by Paxton, works that survey his artistic career from 1906 until 1938. Paxton's portrait of his wife in *The Red Fan* (1906) is a superb example of the American realist taste for depictions of the middle class.

R.H. Ives Gammel (1893-1981) was a student at the School of Boston Museum of Fine Arts before he went to France, both as a soldier in the U.S. Army during World War I and as a student of French academic painting. Upon his return to the United States, despondent over the trends in modern art in Europe, he sought out William McGregor Paxton and ultimately established an American school of academic painting, which became known as Classical Realism. In keeping with his academic style, Gammel was particularly inclined to paint subjects from biblical themes or classical literature. In one of Gammel's most ambitious works, *The Dream of the Shulamite,* he illustrated a maiden's dream from the Song of Solomon in the Old Testament. Of the painting he said:

> "Somehow the passage from the Song of Solomon became a symbol to me—of the sad predicament of idealism, of ideal beauty, of the artistic ideal especially in this brutal age. This same predicament, in this case that of the artist, is expressed by Wagner in a passage of haunting beauty in the third act of *Die Meistersinger.* The Bible verse and the Wagnerian excerpt, the two passages, got assimilated in my mind with the result that now hangs on the walls of Maryhill . . ."

The artist Richard Lack (b. 1928) was a student of R.H. Ives Gammel in Boston and perpetuated the tenets of Classical Realism. Maryhill's *The Concert* (1961) by Lack, in which a couple play a duet in a typical American living room, is an example of the academic style used in a contemporary genre setting.

Left: **William McGregor Paxton (American, 1869-1941), *The Red Fan*, 1906, oil on canvas, 48 x 72 inches. Museum purchase.** Photograph by Jerry Taylor.

Above: **R.H. Ives Gammell (American, 1893-1981),** *The Dream of the Shulamite,* **1934, oil on canvas, 67 x 81.5 inches. Museum purchase.**
Photograph by Jerry Taylor.

Left: **Edwin Howland Blashfield (American, 1848-1936),** *The Musician,* **c. 1880, oil on canvas, 26 x 36 inches. Museum purchase.**
Photograph by Jerry Taylor.

Above: **Richard Lack (American, b. 1928),** *The Concert,* **1961, oil on board, 24 x 26 inches. Museum purchase.** Photograph by Russ Keller.

Right: **Detail, Jacob Bogdani (Hungarian, d. 1724),** *Fruit, a Monkey, and a Parrot,* **n.d., oil on canvas, 25 x 29 inches. Museum purchase.**
Photograph by Nayland Wilkins.

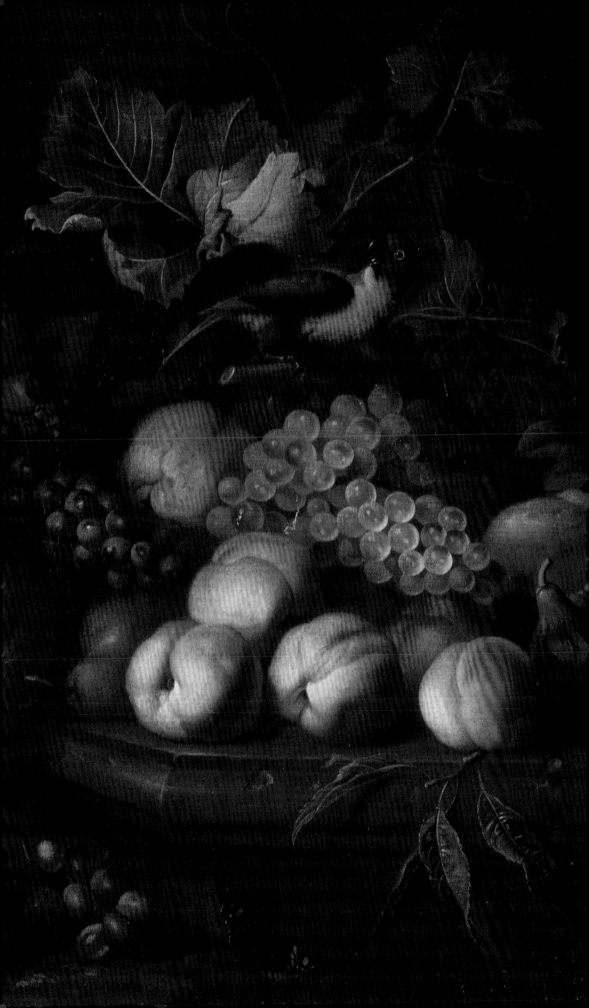

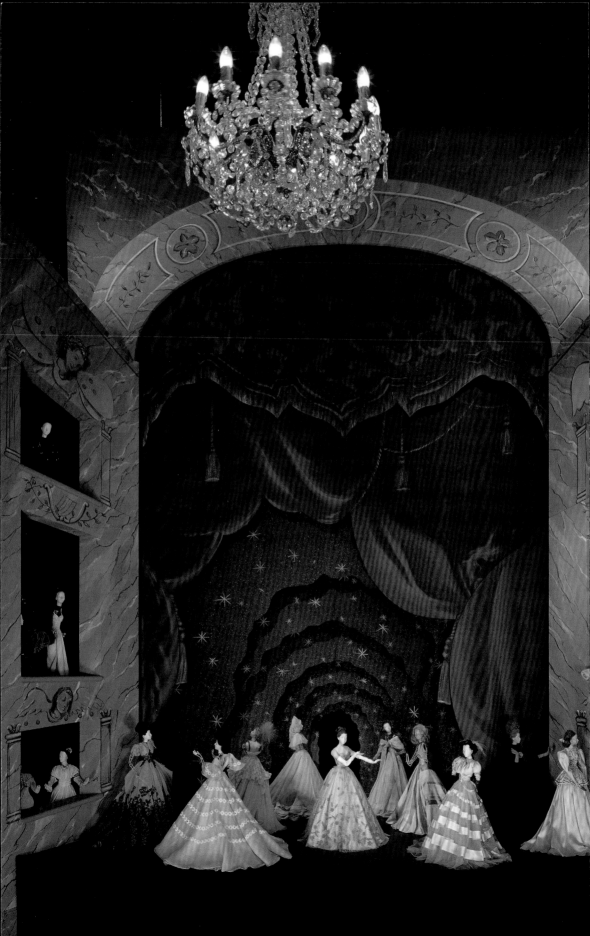

### The *Théâtre de la Mode:* Triumph of French Fashion

Although in August 1944 the streets of Paris erupted with the celebration of the city's liberation from German occupation, the war continued and conditions were increasingly miserable. The French economy lay in ruins; adequate shelter, food, and clothing were in short supply. The winter of 1944-45 brought the iciest cold Paris had known in years, but heating fuel and gasoline were scarce. So, too, was the electricity needed to power the rebuilding of the nation. It was in this gloomy time that the haute couturiers of Paris conceived and executed the remarkable *Théâtre de la Mode.*

In the fall of 1944, Robert Ricci, director general of the house of Ricci and member of the Chambre Syndicale de la Haute Couture Parisienne, was approached by the president of L'Entraide Française. This was the organization responsible for securing and distributing war relief, a formidable but crucial task. The Chambre Syndicale was asked to organize an event that would show the continued vitality of the couture and fashion industries and, at the same time, prove their concern for all those who were in need of help. Paul Caldaguès conceived the brilliant idea of dressing small dolls—reviving a tradition that dated back to the days of Louis XIV—as models of the designers' 1945 collections, thereby conserving scarce fabric, leather, and fur. Robert Ricci suggested arranging the figurines in front of miniaturized theatrical sets designed by the most important graphic designers of the day. "It was I who had the idea . . . of a little theater in which [each artist] would build his set. . . and we would place in them the dolls dressed by the couturiers. And it was then that I thought we should name it the *Théâtre de la Mode,*" said Robert Ricci.

Above: **Jean Saint-Martin working on the wire structures of the mannequins.**
Photograph by Robert Doisneau/Rapho.

Left: *The Theater* **set design by Christian Bérard (French, 1902-1949) for the** *Théâtre de la Mode,* **1945 (re-created in 1990 by Anne Surgers), 29 x 20.5 x 11.75 feet.**
Photograph by Laurent Sully-Jaulmes.

Next, Robert Ricci asked a young artist, Eliane Bonabel, to make some sketches for the prototype of the mannequin form. "We immediately thought that these dolls should not be too solid as this would be reminiscent of a toy. I thought of something transparent. . . my point of departure was the tables of measurements found in fashion magazines at the time." Mademoiselle Bonabel then collaborated with the artist Jean Saint-Martin to design 27$\frac{1}{2}$-inch mannequins fashioned of wire, figures that lyrically traced the female form in three dimensions. The Catalan refugee artist Joan Rebull was asked to sculpt heads out of plaster of Paris.

The wire mannequins were distributed to the couture houses for dressing. All of the most important and prestigious designers were enthusiastic participants: Balenciaga, Pierre Balmain, Jacques Fath, Jacques Heim, Lucien Lelong, Jeanne Lanvin, Nina Ricci, Paquin, Jean Patou, Schiaparelli, Madame Grès, Worth, and many others set to work creating their designs in miniature. The enthusiasm was palpable as the designs took shape. The clothes were made as exact miniatures of full-size fashions, detailed with the same precision and perfection as

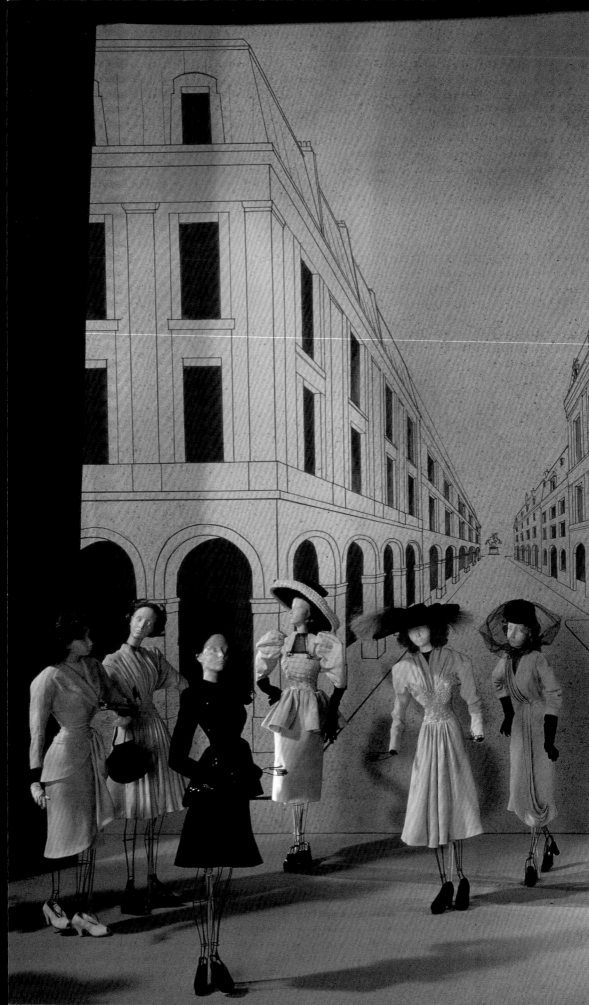

an original couture garment. Buttons could really be unbuttoned; pockets were genuine; belts buckled. Some designers even created tiny underpinnings, although these would never be seen. Accessories—shoes, purses, hats, gloves, and umbrellas—were crafted; important jewelers, such as Van Cleef & Arpels and Cartier, created real brooches, tiaras, epaulets, and even plastrons to complement the fashions. The great coiffeurs of the era created hairstyles to scale, using both human hair and more unusual materials such as metallic thread or twine.

The stage sets that were created as backdrops for the little mannequins were equally elaborate. Christian ("Bébé") Bérard was named artistic director, and he recruited his friends André Beaurepaire, Jean Cocteau, André Dignimont, Georges Douking, Georges Geffroy, Emili Grau-Sala, Jean-Denis Malclès, Joan Rebull, Jean Saint-Martin, Emilio Terry, Louis Touchagues, and Georges Wakhevitch to design stage sets. The sets were designed to suggest different times of day so that morning, afternoon, or evening clothes could be paired with the scenery. Christian Bérard's set represented a theater-opera house, with an elaborate faux-marble colonnade and box seats. Jean Cocteau designed a surrealistic set evocative of the devastation of war. In a tribute to René Clair's film *Ma Femme est une Sorcière (I Married a Witch,* 1942), Cocteau positioned a Pierre Balmain–clad *sorcière* on a broom, flying through a bomb-hole in the roof of a Parisian garret.

To complete the ambience of the *Théâtre de la Mode*, the great Ballets Russes impresario Boris Kochno conceived a magical lighting for the mannequins within the stage sets, while incidental music was composed especially for the *Théâtre* by Henri Sauguet.

The exhibition opened on the evening of March 27, 1945, at the Pavillon Marsan, a wing of the Musée des Arts Décoratifs. A dazzling success, the exhibition was extended for several weeks. Starved for beauty, glamour, and amusement after four years of occupation, Parisians flocked to the *Théâtre de la Mode* to glimpse, even for a few moments, the essence of French style.

Just two days before the *Théâtre de la Mode* was scheduled to close on May 10, 1945, the war ended. By this time 100,000 visitors had seen the *Théâtre de la Mode,* and L'Entraide Française had received about a million francs as a result. The more lasting legacy was the triumphant return to optimism engendered by the magical presence of the little mannequins. From Paris the *Théâtre de la Mode* went to London as "The Fantasy of Fashion," then on to Leeds, Barcelona, Copenhagen, Stockholm, and Vienna. In the spring of 1946, the Chambre Syndicale sent an updated version—complete with the newest fashions—to the United States, where the *Théâtre* opened at the opulent Whitelaw Reid mansion in New York City. The *Herald Tribune's* May 2, 1946, coverage of the exhi-

Left: **Detail of *Parisian Street Scene* set design by Georges Wakhevitch (French, 1907-1984) for the *Théâtre de la Mode*, 1945 (re-created by Anne Surgers in 1990), 132 x 80 inches.** Photograph by Laurent Sully-Jaulmes.

bition raved, "It is typical of the French spirit that artists, sculptors, and stage designers have collaborated with the houses of haute couture to create this magic. Whether one turns to the opera, to the street fair, to the night scenes, to the familiar streets, there is the same dignity, the same grace, the same poetry, telling the heroism of a city that in spite of terror and suffering saved itself whole, preserving alike its good taste, its loyalty to beauty and its indefatigable skills."

The final venue for the little French fashion mannequins was at the De Young Museum in San Francisco in September 1946; following the close of the exhibition there, the mannequins were stored by Paul Verdier in the basement of his City of Paris department store. The real jewelry was returned to France, but the actual dolls, clothes, and stage designs were abandoned in San Francisco.

Through the patronage of Alma de Bretteville Spreckels and Paul Verdier, the mannequins—minus their fabulous theatrical sets, which were presumed destroyed—were given to Maryhill Museum in 1951 and opened the Maryhill season in 1952. In the decades since then, museum visitors have been mesmerized by the curious little figures, intrigued by the dated fashions and elaborate accessories.

In the late 1980s the mannequins were rediscovered by the French fashion industry, thanks to the efforts of Stanley Garfinkel, professor of history at Kent State University, who brought this "lost" episode of history to their attention. By this time the mannequins and their clothes had suffered from years of neglect. In 1988 the mannequins were returned to France, on loan to the Musée des Arts de la Mode, the subject of a major restoration project to conserve the delicate fashions and re-create nine of the original 13 stage sets. Eliane Bonabel was still alive to assist in the restoration of the wire figures, while two of the stage set designers, André Beaurepaire and Jean-Denis Malclès, were also still alive to re-create their own décors. The resurrected *Théâtre de la Mode* opened auspiciously at the very site of its origins, the Pavillon Marsan, in May 1990, where *tout Paris* marveled at this assemblage, a snapshot of a watershed moment in the history of fashion. From Paris the collection traveled to the Costume Institute of the Metropolitan Museum of Art in New York and the Hanae Mori Fashion Foundation in Tokyo.

The *Théâtre de la Mode* at the Maryhill Museum is the embodiment of collaborative innovation and creative genius. As a unique historic documentation, the mannequin tableaux constitute a time capsule of World War II fashion at the eve of Christian Dior's New Look of 1947, which revolutionized the way women dressed. As an example of the *esprit de corps* and the *esprit du temps* of 1945-46, the small mannequins and their re-created sets allow a key moment in French history to live on for current and future generations.

Right: **Detail of *The Enchanted Grotto* set design by André Beaurepaire (French, b. 1924) for the *Théâtre de la Mode*, 1945 (re-created by Anne Surgers in 1990), 147 x 80 inches.**
Photograph by Laurent Sully-Jaulmes.

Overleaf: **Homage to René Clair: "I Married A Witch" set design by Jean Cocteau (French, 1889-1963) for the *Théâtre de la Mode*, 1945 (re-created by Anne Surgers in 1990), 156 x 68 inches.**
Photograph by Laurent Sully-Jaulmes.

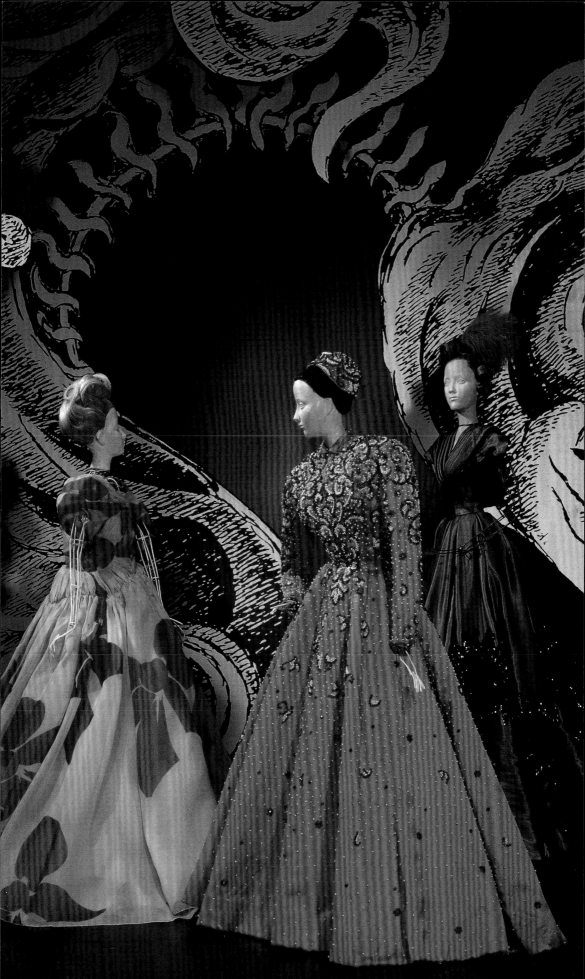

## The Native American Collection

The arts and cultures of the indigenous peoples of North America are represented at Maryhill Museum by the Native American collection. For centuries, the Columbia Gorge has been a richly populated region for Native Americans as well as a major confluence for tribes from throughout the region, bringing together diverse native peoples for intertribal commerce. The bounty of the Columbia River—an abundant source of salmon in earlier years—made the gorge a stable living environment. Just west of the museum is the now-flooded Celilo Falls, the site where Indians balanced on platforms over the edge of the falls, fishing with dip-nets and spears. The well-known ancient petrogylph "She Who Watches" is located just a few miles farther west at Horsethief Lake State Park.

The Maryhill collection well illustrates the close relationship native cultures have with nature; life, of course, depended upon the skilled use of plant and animal materials for all functional objects. Before Europeans came to the New World, the original inhabitants of North America produced a variety of artifacts to meet the practical demands of everyday life. These objects were also beautifully made and decorated.

The Maryhill Museum Native American collection began with a group of baskets acquired by Sam Hill, but quickly grew to include collections amassed by private collectors. Most prominent among these donors are the Underwood Lane family, the Reverend William C. Curtis, William R. Howell, Dr. and Mrs. G.N. Gammon, and Dr. W.M. Fitzhugh Jr. and Marion E. Fitzhugh. In fact, baskets are a specialty of the Native American collection. Virtually every North American basketry tradition and technical style is represented, from a tiny Pomo basket less than one inch in diameter to a four-foot-tall Apache storage basket, called an "olla." Examples of plaiting, coiling, and twining are evident in the more than 800 baskets in the collection.

Maryhill Museum is located in the heart of the cultural region that anthropologists call the Plateau. Lying between the Rocky Mountains and the Cascade Range, the Plateau was peopled by seminomadic tribes who hunted and fished, and gathered wild roots and berries. The Plateau people were also excellent basket makers, and the Plateau collection at Maryhill is particularly noteworthy. Included are Wasco twined bags, twined cornhusk bags, and Klikitat and Interior Salish–style coiled baskets, as well as beaded bags and clothing, tools, utensils, toys, and games.

The Maryhill collection spans centuries, starting with ancient stone sculpture and rock images. More recent objects illustrate the European impact on native cultures with the introduction of new material goods. Glass beads, trade cloth, modern aniline dyes, coins, and metal tools (such as thimbles) were eventually incorporated into native designs.

The Native American collection at Maryhill Museum is a striking contrast to the European art and artifacts exhibited elsewhere in the mansion. Yet given the rich Native American heritage of the Pacific Northwest, the Native American collection is an eloquent illustration of why Sam Hill had a lifelong fascination with the indigenous peoples of his adopted state.

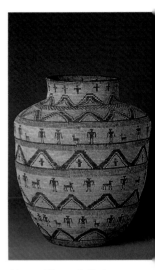

Above: **Olla or Coiled Basketry Jar (Apache),** mid-late 1800s, willow and martynia, 11.5 x 29.5 inches. Gift of Dr. W. M. Fitzhugh Jr. and Marion E. Fitzhugh.
Photograph by Jerry Taylor.

Left: **Native American Woman's Dress (Plateau),** 19th century, leather and shells, 52 x 54 inches. Anonymous donor.

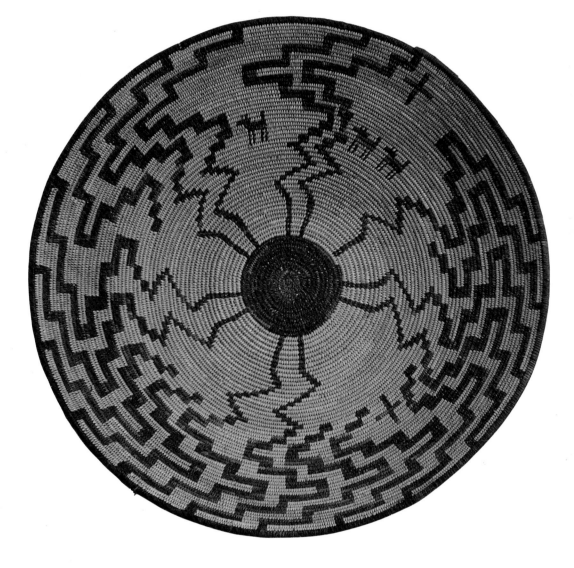

Above: **Native American tray (Apache), mid-late 1800s, willow and martynia, 18.5 inches diameter x 4.5 inches. Gift of Mr. and Mrs. John R. Holmes.**

Left: **Etched tusk made by Joe Kakayook (Eskimo), 19th century, ivory (seal or walrus tusk), 11 x 1.5 inches. Gift of H.T. and Bessie Day Harding.**

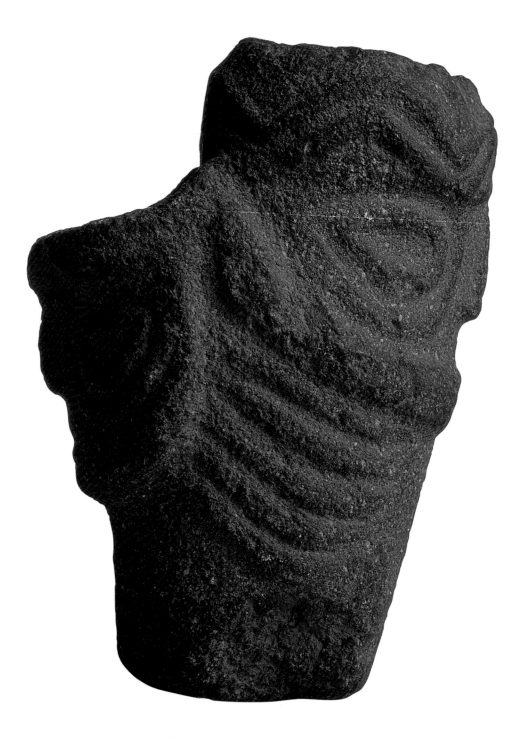

Above: **Mortar (Plateau), pre-19th century, basalt, 4 x 4 x 11 inches. The Walter Klindt Collection.**

Right: **Octopus Bag (Wasco-Wishxam), c. 1840, cotton string and glass beads, 16.75 x 7 inches. Gift of Mary Underwood Lane.**

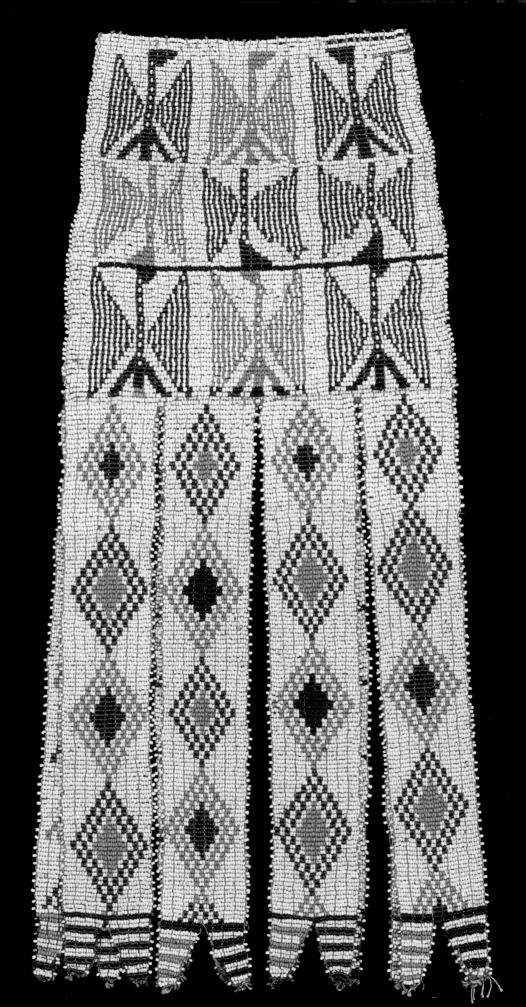

Above: **North West Company fur trade tokens on rawhide string, 1820. Gift of Mary Underwood Lane.**

Left: **Detail of a Klikitat basket (Klikitat), 19th century, split cedar root and beargrass, 10.25 x 5 x 3 inches. Gift of Louise Miller.**

# MARYHILL SINCE ITS FOUNDING
## EPILOGUE

At the time of Sam Hill's death in 1931, much work lay ahead to finish his mansion and transform it into a museum of art. Funds to complete the building were not immediately available because the million-dollar endowment Sam left for the operation of the museum was contested in a legal battle over his estate—litigation that dragged on until 1937. Furthermore, although the museum had been incorporated in July 1923 and a board of trustees appointed to bring it to fruition, the trustees lived as far away as Seattle, San Francisco, Philadelphia, and Paris. Work on the remodeling finally began in 1938, the same year the museum was supplied with electricity. At that time the mansion-museum's interior had floor-to-ceiling concrete walls, with metal studs jutting out and metal lathe exposed. Floors had to be laid. The original plumbing, which didn't drain properly, had to be replaced; the elevator shafts were empty.

The board called on Clifford Dolph, who was a nephew of one of the trustees and had previous museum experience. Dolph was hired to construct exhibition furniture, unpack the crates that had held the collections for years, and set up displays. Thanks to his yeoman efforts, and much work by Alma de Bretteville Spreckels, Maryhill Museum was opened to the public on May 13, 1940. Dolph remained the director for 33 years, until his retirement in 1972, living for many of those years with his family in the lower level of the museum.

Above: **The ten-headed demon king Ravana from an ivory Indian chess set, 20th century, 1.5 x 3.5 inches. Museum purchase.**
Photograph by Bill Bachhuber.

Clifford Dolph made progress in many areas of the museum's operation, but his most visible legacy is the chess set collection—the only collection in the museum that does not pertain to any of the four founders. Dolph was an avid chess player and, for lack of nearby opponents, played the game with other chess aficionados through the mail. In 1957, Dolph organized a special exhibition for the museum of chess pieces as examples of decorative art, including over 1,600 pieces from collections all over the world. The exhibition was so popular that its run was extended twice. With the encouragement of the board of trustees, the museum's resident chess enthusiast then began to develop a permanent collection of chess sets. Between 1957 and Dolph's retirement, the museum amassed a collection representing many countries, cultures, and historic periods. While two other public collections of chess sets exist in the United States—one at the Metropolitan Museum of Art in New York City and one in the Cleveland Public Library—Maryhill Museum's collection is the most extensive on continuous display.

None of Maryhill's collections delights visitors of all ages more than its collection of chess sets and gaming pieces. These sculptures-in-miniature illustrate the enormous range of creativity and decorative possibilities suggested by one idea: the game of chess. The museum owns nearly 300 sets of chessmen and other game-markers. Among them are pieces made of every imaginable material: ivory, bone, stone, wood, precious

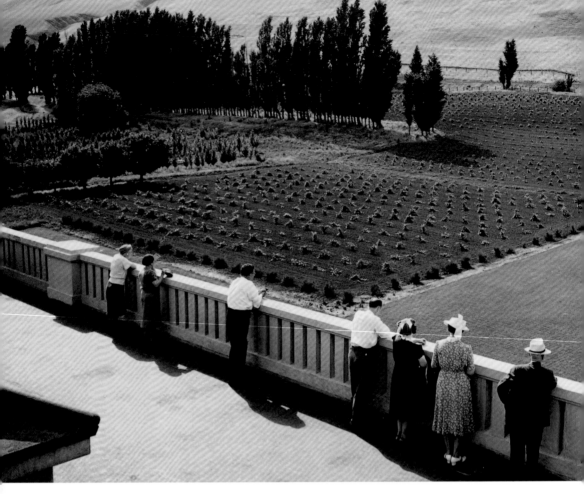

Above: **View of the Grand Lawn and vineyard from the roof of Maryhill Museum, 1940. Although this vineyard no longer exists, the museum continues to make innovative use of the expansive property.**
Photographer unknown.

Right: **Charles M. Russell (American, 1864-1926),** *Indian Buffalo Hunt,* **1896, oil on canvas, 35 x 25 inches. Gift of Jeanne Wertheimer in memory of her husband, Phillip M. Wertheheimer.**
Photographer unknown.

metal, porcelain, ceramic, and glass, as well as more modern materials such as plastic and base metal.

Hindu gods, Eskimos, African animals, clergy, political personalities, fairy-tale figures, and other fanciful creations stand ready to take on their opposing forces on a multitude of chessboards. Intricate craftsmanship is evident in Chinese chess pieces carved atop puzzle-balls or in the exquisitely carved Barleycorn style, so named because the barleycorn leaf and husk are stylized elements in early examples.

Maryhill Museum's chess set collection attracts more gifts than any of its other collections. Serious chess collectors have identified the importance of the Maryhill collection and continue to generously donate further examples of artistic gaming pieces.

After Clifford Dolph's retirement, the board of trustees in January 1975 hired a new director, Robert Campbell, a Portland stockbroker and private collector of Native American and African art. While Robert Campbell breathed a different kind of energy into the institution, establishing more public programs, developing new exhibits, and attracting conservation funds, the next few years were troubled at Maryhill Museum, as both the governing body and administration of the museum came under legal and public scrutiny. Because of alleged mismanagement of the museum's collections and funds, a concerned museum member, Mary Hoyt Stevenson of White

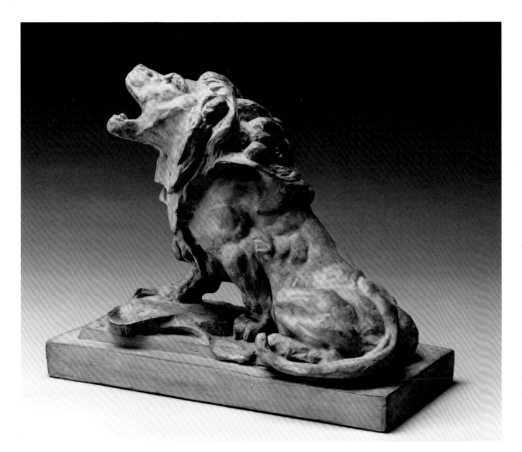

Salmon, Washington, contacted the Washington State Attorney General's Office and requested an investigation of the museum's operations. (The museum, as a private, nonprofit corporation, was and is a charitable trust whose beneficiary is the general public.) In a flurry of accusations, a lawsuit, and a counter-suit, the museum's second director was asked to resign in March 1976, only 15 months after he had been hired. The state attorney general expanded the formerly small board by appointing five new trustees, and worked with the museum in rewriting its bylaws to reflect prevalent professional museum standards.

The questionable policies and practices during the formative years of the museum were the result of poor judgment and ignorance, certainly not malice. Nonetheless, this time of maturation for Maryhill Museum came at a high cost. For a cultural institution already challenged by its geographic location, this period was particularly difficult.

Resolution of these problems came about through the determination of the board of trustees and staff. With help from the Washington State Attorney General's Office, the management of Maryhill Museum slowly turned around. With new bylaws in place, additional trustees with diverse skills and interests were brought on board to govern a membership-based organization. Trustee orientation was made mandatory so that all trustees understood their fiduciary responsibilities.

Above: **Auguste Rodin (French, 1840-1917),** *Crying Lion,* **1881, terra cotta, 13 x 6.25 x 11.5 inches. Gift of Iris and B. Gerald Cantor.**
Photograph by Bill Bachhuber.

Left: **Chess set made by SKF Svenska Aktiebolaget Göteborg (Swedish), c. 1950, gilded and silvered steel ball bearings. Gift of Erwin Ezzes.**

The museum hired new staff members with essential professional training. Proper collection management procedures were established in accordance with recommendations set forth by the American Association of Museums, and financial reviews became a priority.

Having gone through a very public baptism by fire, Maryhill Museum today is considered to be in the forefront of its field for its complete compliance with accepted museum standards. Evidence of this is the number of federal and state merit grants the museum has received in the years since. In 1988 the museum received an Institute of Museum Services merit grant to reinstall the Native American collection; a Washington State Arts Commission grant (1992-99), Cheney Foundation grants (1995 and 1998), and a Washington State Capital Heritage grant in the amount of $500,000 (1997) have followed. In 1995 and 1997 the U.S. Department of Transportation and the Washington State Department of Transportation supported the rehabilitation of the historic Loops Road with over $500,000 in funding. Such recognition acknowledges the importance of Maryhill Museum as well as indicating sanction of the strides made by the museum's board and administration.

A high point in the history of Maryhill Museum was the *Théâtre de la Mode* project to completely restore the small French fashion mannequins and re-create nine of the 13 original stage sets in which they were displayed. The mannequins and stage sets, originally created in 1945-46, were returned to Paris for conservation, a process that took two years (1988 to 1990). When the *Théâtre de la Mode* was unveiled in Paris in its restored splendor, the dolls created an international sensation. Exhibited at the Musée des Arts de la Mode in Paris (1990), the Costume Institute of the Metropolitan Museum of Art in New York (1990), and the Hanae Mori Foundation in Tokyo (1991), and later at the Portland (Oregon) Art Museum, the Baltimore Museum of Art, and the Imperial War Museum in London, the little mannequins became ambassadors not only of fashion, but of Maryhill Museum, calling international attention to this rural art resource.

Maryhill Museum is a thriving and growing institution. Its collections continue to attract important donations that strengthen and enrich its holdings. Because of the Queen Marie of Roumania collection, in 1988 the museum received a major endowment from Mrs. Irene Comnene Bie-Corsani, the daughter of Ambassador Nicholai Comnene and his wife, Antoinette, who served Roumania under King Ferdinand and Queen Marie. Mrs. Bie-Corsani's gift included funds to maintain a gallery dedicated to her parents, as well as more than 200 examples of the Roumanian folk costumes and textiles so loved by Queen Marie, and a Russian icon that had belonged to the Stroganoff family.

In 1990 the foremost private collectors of Auguste Rodin sculpture, Iris and B. Gerald Cantor, donated an early Rodin terra cotta sculpture called *Crying Lion* (1881) to the collec-

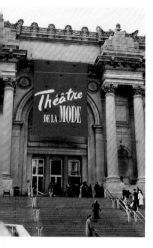

Above: **The French fashion mannequins and their newly created stage sets were heralded at the Costume Institute of the Metropolitan Museum of Art in New York in December 1990.** Photograph by Linda Tesner.

Right: **In 1998 the museum was able to purchase a rare 1904 portfolio on Loie Fuller by the critic Roger Marx (French, 1859-1913) and the artist Pierre Roche (French, 1855-1922) with funds from the Mary Hoyt Stevenson Foundation. Roche illustrated the portfolio with embossed prints (called "gypsographs") portraying the dancer. These he made by creating a plaster mold of Loie's portrait, then pressing wet paper into the mold to create a subtle bas-relief. 8 x 10.5 inches, closed.**

*Ménades du Thiase de Dionysion et avec les danseuses sublimes qui inspirèrent à Paeonius sa Victoire, aux coroplastes de Tanagra leurs figurines, aux peintres le décor des céramiques précieuses et l'illustration murale des villas pompéiennes.*

*Le temps qui vit Loïe Fuller chercher à Paris la consécration de sa gloire était cet hiver de l'an dix-huit cent quatre-vingt-douze, pendant lequel le goût français attestait sa lassitude pour les libertés de la chorégraphie fin de siècle et pour l'exotisme des girations musulmanes, invariables comme les mélopées qui les provoquent. En vain se serait-on pris à espérer des théâtres d'État l'exemple des initiatives et des renouvellements; la science du ballet y régit, assujettie à des règles, elles aussi, fixes et*

*10*

*caduques. Par bonheur, l'atticisme affiné de Loïe Fuller allait apporter la diversion utile à tant de redites et d'extravagances...*

*Mettez à part quelques flexions du buste en arrière, une imitation passagère et assez lointaine du matin trépignement andalou, plus de déhanchements, plus de contorsions, plus de cambrures ni de mouvements circulaires du bassin; de même c'en est fait des pointes, des jetés-battus, des entrechats et de ces exercices de gymnastique disloquante par où se traduisent uniformément, à l'Opéra, tous les sentiments et les plus dissemblables émois. Nos ballerines s'ingénient à se dévêtir de leur mieux ; ici, au contraire, le visage seul émerge d'une longue blouse qui marque à peine la taille et touche au sol ; l'animation et l'envol des plis flottants fournissent à Loïe Fuller le texte et les variations de son art. Peu importent les dispositions de ses robes magiques et leur très relatif symbolisme ! Que les bords s'enguirlandent de ruches et de roses, que les pans s'armorient de serpents tortueux aux écailles d'argent, ou bien encore qu'ils se constellent de papillons déployant le miroir de leurs*

tion. Another important addition to the Rodin collection is an educational series of bronze castings illustrating the complicated technique of lost wax casting; this set was purchased for the museum with funds from the Arthur Dunn Guild of Seattle. A major addition to the paintings collection came when the work *Indian Buffalo Hunt,* by Charles M. Russell (page 113), was given by Jeanne Wertheheimer, a Longview, Washington, resident. This excellent example of Western art complements the Native American collection in its depiction of the Plains Indians' traditional quest for buffalo.

The Native American collection, too, grows through gifts and purchases. One such acquisition is a Klikitat "Indian wedding veil," a beaded headdress worn by Plateau women when they married. Other additions include purchases made directly from well-known Native American artists working in traditional methods. Cedar bark baskets by Warner Jim and Lindsey Howtopat, twined bags by Sally Slockish Buck and Pat

*This Klikitat wedding headdress worn by Plateau women is an excellent example of traditional materials augmented by the introduction of European materials. The veil incorporates not only natural leather and shells but also glass beads, thimbles, bells, and coins.*

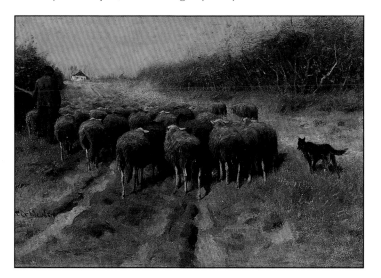

Courtney Gold, a coiled berry-picking basket by Nettie Jackson, a beaded handbag by Sophie George, a bronze mask of "She Who Watches" by Lillian Pitt, and a beaded cradle board by Maynard White Owl Lavadour are pieces of contemporary Native American art that have been added to the collection.

The story of Maryhill Museum has evolved over most of the 20th century. Initiated by four friends with a shared vision, the history of Maryhill Museum has unfolded in curious, charming, and sometimes startling ways. Fully established as one of the most cherished—and unusual—cultural resources in the Pacific Northwest, the museum now looks to a secure and promising future. And what would Sam Hill, Queen Marie of Roumania, Loie Fuller, and Alma de Bretteville Spreckels think of the remarkable development of Maryhill Museum, which has emerged, like one of Loie's butterflies, from the chrysalis of a dream? One can't help thinking they would approve.

Inset: **Francois Pieter ter Meulen (Dutch, 1843-1927), untitled (*Morning*), c. 1880, oil on canvas, 38.5 x 29 inches. Gift of Geraldine Kangley.** Photograph by Nayland Wilkins.

Left: **Detail of a Native American "Wedding Veil" (Klikitat), c. 1850, glass, metal beads, leather, dentalium shells, thimbles, bells, Chinese coins, 22 x 10 inches. Museum purchase.**

## An Update

Since the *Maryhill Museum of Art* guidebook was published in 2000, many marvelous advancements have taken place at the museum. Thanks to the diligent efforts of the board and staff, Maryhill Museum was accredited by the American Alliance of Museums in 2002 and successfully completed reaccreditation in 2016. These steps assure that the Maryhill Museum resources—its historic mansion, ranchlands, art and artifacts—will be preserved for future generations.

Today, the museum has an eight-person full time staff, which expands seasonally to accommodate the approximately 45,000 local, regional, and international visitors annually. There have been some momentous improvements to the museum's physical facilities, all of which combine to strengthn the museum's fiscal health, and the quality of the visitor experience.

The legendary and relentless Columbia Gorge wind provided an unusual financial boost for the museum when, in 2009 the museum contracted with Cannon Power Group, a California company that leases land from Maryhill Museum to operate a wind farm called Windy Flats. With fifteen wind turbines turning on the rolling swells of the surrounding landscape, the twenty-year lease generates about a quarter of a million dollars per year for the museum's annual operating budget. Capturing the natural resource of wind as a revenue source is yet another way in which Maryhill Museum is unique; according to the American Wind Energy Association, this is believed to be the first wind energy project in the United States to generate revenue for a nonprofit museum.

The most spectacular achievement made by Maryhill Museum of Art in the past several years is that, in 2012, the museum dedicated the Mary and Bruce Stevenson Wing, a ten million dollar expansion that yielded more than 10,000 square feet of additional interior space and more than 11,000 square feet of exterior plazas and terraces. The architectural expansion was designed by Gene Callan of GBD Architects, Portland, Oregon. The added space has provided expanded exhibition space for the museum's chess set collection, as well as much-needed collections management storage and a room for educational programs. The café was relocated from the west rotunda, where the sound of espresso machines could be heard while viewing the Rodin collection. It is now located in the expansion, where visitors to the café are able to walk outside and take in the spectacular Gorge views on the café patio. The museum has also recently received a stucco and roof preservation face lift, which heightens the grandeur of the mansion and further protects the cultural artifacts inside.

Maryhill Museum remains a singular historical and art museum. Approaching its one hundredth anniversary, in 2026, the museum has successfully faced innumerable challenges and opportunities to bring one of the most extraordinary museum experiences to its visitors.

Left: **The Laura and John Cheney Gallery in the Mary and Bruce Stevenson Wing.**

Overleaf: **Maryhill Museum of Art as seen from the Oregon side of the Columbia River.**

Above: **Thomas Jefferson Kitts (American, b. 1961),** *Sacred Rights,* **2016, oil on canvas, 16 x 20 inches. Museum purchase, Collection of Maryhill Museum of Art, 2016.**

Left: **Maryhill Museum of Art Terrace and Vineyards above the Columbia River.**

Above: **Rick Bartow (American [Wiyot]. 1946–2016),** *Avery's Hawk,* 2008,
pastel and graphite on paper, 44 x 30 inches; Gift of the Estate of
Richard E. Bartow and Froelick Gallery, in honor of Anne Avery,
Collection of Maryhill Museum of Art.

Right: **James Lee Hansen (American, b. 1925),** *Winter Rider Variation,*
2010, bronze 70 x 15.25 x 39 inches. This work is being purchased
and donated by Bill and Cathy Dickson.

## Selected Bibliography

Butler, Ruth. *Rodin: The Shape of Genius.* New Haven, Connecticut: Yale University Press, 1993.

Charles-Roux, Edmonde, Herbert R. Lottman, Stanley Garfinkel, Nadine Gasc, Katell le Bourhis, and Susan Train, ed. *Théâtre de la Mode.* New York: Rizzoli, 1990.

Current, Richard Nelson, and Marcia Ewing Current. *Loie Fuller: Goddess of Light.* Boston: Northeastern University Press, 1997.

De Caso, Jacques, and Patricia B. Sanders. *Rodin's Sculpture: A Critical Study of the Spreckels Collection.* San Francisco: The Fine Arts Museums of San Francisco, 1977.

Elsen, Albert E., ed. *Rodin Rediscovered.* Washington, D.C.: National Gallery of Art, 1981.

Elsen, Albert E., and J. Kirk T. Varnedoe. *The Drawings of Rodin.* New York: Praeger Publishers, 1971.

Elsen, Albert E. *The Gates of Hell by Auguste Rodin.* Stanford, California: Stanford University Press, 1985.

Frel, Jiří, and Harvey West. *Rodin: The Maryhill Collection.* Pullman, Washington: Washington State University Press, 1976.

Fuller, Loie. *Fifteen Years of a Dancer's Life.* New York: Dance Horizons, 1913.

Gammell, R.H. Ives, and Elizabeth Hunter, ed. *The Boston Painters 1900-1930.* Orleans, Massachusetts: Parnassus Imprints, 1986.

Grunfeld, Frederic V. *Rodin: A Biography.* New York: Henry Holt and Company, 1987.

Güse, Ernst-Gerhard. *Auguste Rodin: Drawings and Watercolors.* New York: Rizzoli, 1985.

Harris, Margaret Haile. *Loïe Fuller: Magician of Light.* Richmond, Virginia: Virginia Museum of Fine Arts, 1979.

Lack, Richard, ed. *Realism in Revolution: The Art of the Boston School.* Dallas, Texas: Taylor Publishing Company, 1985.

Lack, Richard, and R.H. Ives Gammell. *Classical Realism: The Other Twentieth Century.* Springville, Utah: Springville Museum of Art, 1982.

Lee, Ellen Wardwell. *Willliam McGregor Paxton.* Indianapolis: Indianapolis Museum of Art, 1979.

McKenzie, A. Dean. *Mystical Mirrors: Russian Icons in the Maryhill Museum of Art.* Goldendale, Washington: Maryhill Museum of Art, 1986.

Pakula, Hannah. *The Last Romantic: A Biography of Queen Marie of Roumania.* New York: Simon & Schuster, 1984.

Piini, Ernest W. *America's Stonehenge.* Redwood City, California: Sarsen Press, 1980.

Rodin, Auguste. *Rodin on Art and Artists.* Mineola, New York: Dover Publications, 1983.

Schafroth, Colleen. *Sculptures in Miniature: Chess Sets from the Maryhill Museum of Art.* Goldendale, Washington: Maryhill Museum of Art, 1990.

Scharlach, Bernice. *Big Alma: San Francisco's Alma Spreckels.* San Francisco: Scottwall Associates, 1990.

Schlick, Mary Dodds. *Columbia River Basketry: Gift of Ancestors, Gift of the Earth.* Seattle: University of Washington Press, 1994.

Tuhy, John E. *Sam Hill: The Prince of Castle Nowhere.* Portland, Oregon: Timber Press, 1983.

Vita Miller, Joan, and Gary Marotta. *Rodin: The B. Gerald Cantor Collection.* New York: The Metropolitan Museum of Art, 1986.

Warmus, William. *Emile Gallé: Dreams Into Glass.* Corning, New York: The Corning Museum of Glass, 1984.

## Acknowledgments

This book would not have been possible without the information contained in the biographies of Maryhill Museum's four founders. The author is indebted to John E. Tuhy, Hannah Pakula, Richard Nelson Current and Marcia Ewing Current, Margaret Haile Harris, and Bernice Scharlach for their in-depth research on Samuel Hill, Queen Marie of Roumania, Loie Fuller, and Alma de Bretteville Spreckels. These biographers have thoroughly researched their subjects, often through rare primary sources (including records at Maryhill Museum), and deserve recognition as the leading authorities on the individual founders. Other resources, as listed in the bibliography, provided information about the collections.

Several others have been involved in the development of this volume, meant to introduce Maryhill Museum, its colorful history, and its world-class collection to a wider audience. The staff at Maryhill Museum have been particularly helpful; the author and publisher gratefully acknowledge the support given by Colleen Schafroth, director, Steve Grafe, curator of art, and Betty J. Long, retired collections manager. Susan Train, bureau chief of Condé Nast Publications in Paris, has long been a benefactor of Maryhill Museum and not only assisted in acquiring rare photographs of Loie Fuller but also verified information on the *Théâtre de la Mode.* Judy McNally provided an invaluable service through her incisive editing of the text.

International Standard Book Number 0-9642006-2-7
Library of Congress Catalog Card Number: 00-101311
Photography ©MM, ©MMXVII Robert M. Reynolds
Text ©MM, ©MMXVII  Linda Tesner

**Editor** Judy McNally

**Design** Reynolds Wulf Inc.
    Robert M. Reynolds
    Letha Gibbs Wulf

**Typography** Letha Gibbs Wulf

**Production** RLO Media Productions
**Prepress** Mars Premedia
Printed and bound in China

Arcus Publishing
1500 N.W. Bethany Blvd. Suite 180
Beaverton, Oregon
503-228-1859

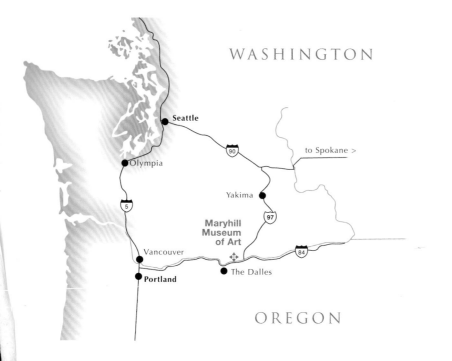

Maryhill Museum of Art
35 Maryhill Museum Drive
Goldendale, Washington 98620

Phone: (509) 773-3733
Fax: (509) 773-6138
maryhill@maryhillmuseum.org
facebook.com/maryhillmuseum
www.maryhillmuseum.org

**Linda Tesner** was raised in Eugene, Oregon; she earned a bachelor's degree from the University of Oregon and a master's degree from the Ohio State University, both in art history. Her affection for the Maryhill Museum of Art grew during her tenure as its director from 1983 to 1992. She was the assistant director of the Portland Art Museum from 1994 to 1998 and is currently director of the Ronna and Eric Hoffman Gallery of Contemporary Art at Lewis & Clark College. She is the author of numerous exhibition catalogues and monographs. She lives in Portland with her husband, John Tesner.

**Robert M. Reynolds** is a graphic designer and photographer with Reynolds Wulf Inc. of Beaverton, Oregon. He is the designer/photographer of many books, including *Oregon Wine Country; Washington Wine Country; Lewis & Clark: From the Rockies to the Pacific; Portland: The View from Here;* and *The Literature of The Lewis & Clark Expedition.*

Reynolds Wulf Inc. (with Letha Wulf) specializes in book design for corporations, history, and art collections. Projects include *Queen Mary 2: The Greatest Ocean Liner of Our Time; Windows On America; Stimson Lumber; Warp and Weft, Chain Stitch and Pearl;* and *Hoffman Construction Company: 75 Years of Building.*

Reynolds Wulf Inc. has designed numerous books, many of which Reynolds also photographed. Reynolds Wulf Inc. is the winner of three national gold metal CASE awards (Council for Advancement and Support of Education).

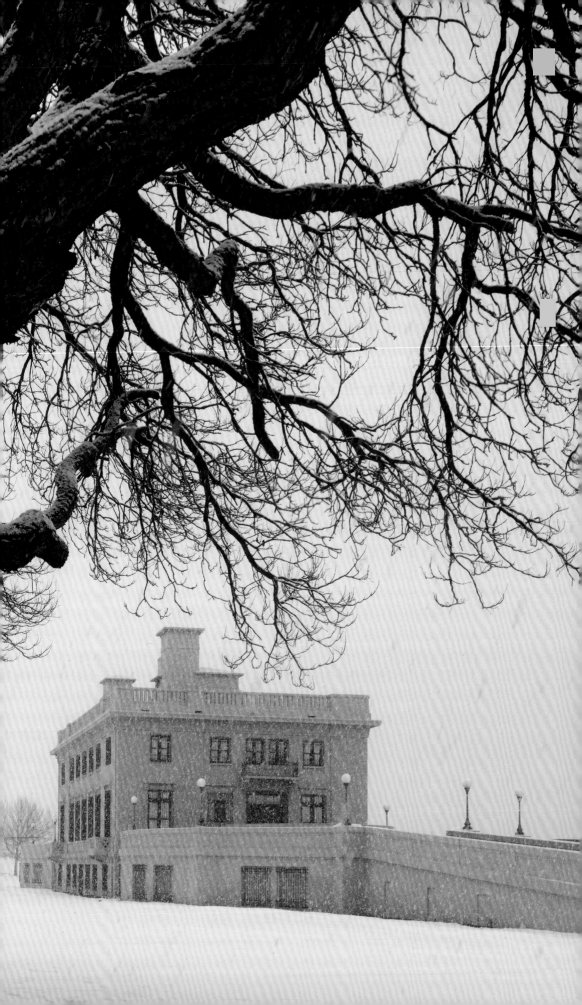